IMAGES
of America

POUND RIDGE

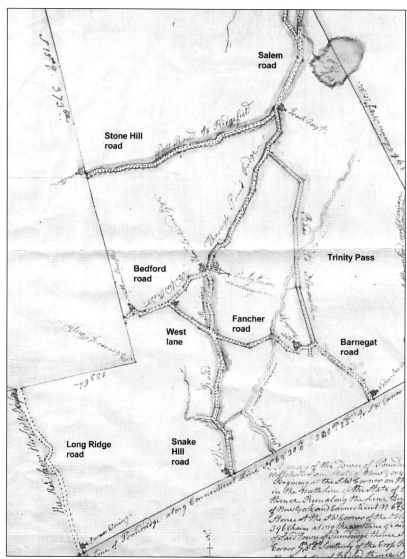

MAP OF POUNDRIDGE, 1797. This 1797 map was created by surveyor Charles Webb for the supervisor of Poundridge, William Fancher. Long Ridge Road was "the road from Stamford to Bedford." Pound Ridge Road was called Bedford Road. The original route from Bedford to New Canaan, Connecticut, was along present-day Pound Ridge Road, on to West Lane, then along Fancher Road and Barnegat Road into Connecticut. The combination of today's Snake Hill Road, High Ridge Road, Westchester Avenue, and Salem Road was "The road running through Pound Ridge." Stone Hill Road, to Old Stone Hill Road, to Salem Road was "the Post Road to Ridgefield." Donbrook Road, Trinity Pass, and Barnegat Road was "the Road to Norwalk." (Courtesy of the Pound Ridge Historical Society.)

On the cover: **BASKET MAKING BY FRED SCOFIELD.** The making of oyster baskets was an important industry in Poundridge from the mid-1800s through the early 20th century. Over 80 Scotts Corners families were engaged in basket making at its peak. This photograph of Fred Bennett Scofield (1866–1950) shows his basket shop. (Courtesy of the Pound Ridge Historical Society.)

IMAGES
of America

POUND RIDGE

Richard Major and Vincent Manna

ARCADIA
PUBLISHING

Published by Arcadia Publishing
Charleston SC, Chicago IL, Portsmouth NH, San Francisco CA

Printed in the United States of America

Library of Congress Control Number: 2009921710

For all general information contact Arcadia Publishing at:
Telephone 843-853-2070
Fax 843-853-0044
E-mail sales@arcadiapublishing.com
For customer service and orders:
Toll-Free 1-888-313-2665

Visit us on the Internet at www.arcadiapublishing.com

*To all those individuals who came before us to make
Pound Ridge the very special, low-density community it is.*

CONTENTS

ACKNOWLEDGMENTS

I would like to thank and acknowledge those who helped make this book possible. First and foremost is Richard Major, my partner in this endeavor, whose vast knowledge of Pound Ridge was so critical to this work. Also to Bonnie Brodnick, who gave the major impetus to this endeavor by connecting Richard, Arcadia Publishing, and myself. Thanks must go my wife, Nancy, and Richard's wife, Joan, who were supportive of our effort and provided us the encouragement and time to complete this work. Special thanks must go to Zachary Manna, whose time with daddy was seriously curtailed.

This book would not be possible without the broader help of many other individuals who contributed in various ways, including Jay Harris, author of *God's Country*, as her work contributed in so many ways to this endeavor; town of Pound Ridge historian Phil Pessoni, "Mr. Boutonville," for his outstanding written and photographic contributions to the Boutonville section; Josina van der Maas for editing and photograph additions; the members of the Pound Ridge Historical Society Board of Directors who supported this effort with encouragement and motivation (Melissa Verdier, Michael Santulli, Mary Anne Condon, Ebie Wood, Joyce Butterfield, Norman Tuttle, Ruth Mendes, Stephanie Susetka, and Murry Levy); and the folks who provided additional photographs (Elyse Arnow Brill, Alice Hand, April Herbert, Ed Isaacs, Regina Kelly, Judy Carman Tomlins, and Peter Uhry). Also, thanks to the many past donors to the Pound Ridge Historical Society who provided the physical items in the society's collection. Without their gifts and bequeaths, the collection would not exist. Thanks go to the many families who have monetarily donated to the society as their funding assists in ongoing procurement of items for the collection. Finally, to the government of the Town of Pound Ridge, which supports the museum building and infrastructure of the Pound Ridge Historical Society in so many ways.

It should be noted that this book would not be possible without the Pound Ridge Historical Society photograph collection. All images are courtesy of the Pound Ridge Historical Society except where noted. All buildings still exist unless stated otherwise.

—Vincent Manna

INTRODUCTION

Pound Ridge is blessed with being located slightly away from main highways, industrial development, and commercial sprawl, thereby providing what local resident Tom Brokaw recently described as a sylvan community. In 1948, the town board decreed that the spelling of the town's name would officially change from Poundridge to Pound Ridge.

The native inhabitants of Pound Ridge belonged to the Siwanoy and Kitchawong, which were Mohegan Indian tribes of the Wappinger Confederacy and part of the Algonquian linguistic group. Pound Ridge derives its name from the remains of an old Native American pound used for the storage of game. The pound existed in the early part of the 1700s. It is believed to have been located on the flat-topped hill near the hamlet, off Pound Ridge Road, or at the southeastern edge of Stone Hills.

Pound Ridge origins stem from the Stamford grant. In 1640, Capt. Nathaniel Turner bought a tract of land from the Sagamores, Ponus, and Wascussue. Stamford's original settlers came out of a dispute between two factions in the town of Wethersfield, Connecticut. The dispute was irreconcilable, and in 1641, one group decided to move on. That summer, following Native American paths and driving their cattle before them, they moved into the Stamford tract that Captain Turner had bought for the colony of New Haven.

In 1667, Pound Ridge became part of the town of Stamford, where proprietors or homeowners received land north of Stamford with their original purchases. Long Ridge Road, originally a Native American path, was a "cartway to ye hopground" by 1681. Then it was called "the Road to Bedford" and was used by those heading north to settle Bedford. The "Great Meadow" that lay on the western side of the Bedford Road, in the vicinity of the Shad Roads, was excellent farmland. Two hundred and fifty years later, this same meadow would be a finalist for the United Nations headquarters. In 1697, William III granted 200 square miles between the Hudson and the Connecticut line to Stephanus Van Cortlandt for a yearly rent of 40 shillings. It included about 3,000 acres of what is now the northern part of Pound Ridge.

In 1702, another part of what is today Pound Ridge was granted by the Crown to a group of land speculators. This was known as the east patent. This early history is a tangle of patent disputes, disagreements over boundaries, conflicting claims, and vague surveys. Families that settled in Poundridge received title to their lands through the Stamford grant by purchase from the east patent owners. The first recorded settlers of Poundridge came in 1718 when the Bush, White, and Waren (Waring) families came from Huntington, Long Island, to the Long Ridge area. It was not until May 14, 1731, that the final settlement of the boundary lines occurred, at which time Pound Ridge was transferred to the province of New York.

In the early years of its settlement, Poundridge was under the jurisdiction of North Castle. Around 1750, the town had begun to acquire an identity of its own. It was known as Old Poundridge and started to elect its own officials. Prominent families, such as Lockwood, Scofield, Fancher, and Selleck, moved into town during the early to mid-1700s. During the French and Indian Wars (1755–1762), 130 Westchester men served under Capt. Rueban Lockwood of Poundridge. Of these, 36 men came from Poundridge. Nine other Poundridge men served under Capt. John Verplank of the Cortlandt Manor grant.

People living in the east patent, east of the Mianus River, were permitted to buy their lands on payment of the quitrents due the Crown in 1766; their titles were validated by the first New York State Constitution in 1777. Between 1789 and 1814, residents of northern Poundridge paid rent to the Van Cortlandt heirs as part of the Cortlandt Manor grant. The Pound Ridge known today was incorporated under the Township Act of 1788, which divided Westchester County into 21 towns.

During the American Revolution, Poundridge was squarely on the side of the patriots. On July 2, 1779, British dragoons led by an up-and-coming officer named Banastre Tarleton raided sleepy Poundridge. Most historians overlook this minor skirmish. However, taken as part of a larger puzzle, the raid on Poundridge was significant in its own right. Westchester was a major travel route from New York to New England. The raid was part of a major British initiative set into motion that would attempt to sever New England from the rest of the colonies. British goals for the raid included a desire to terrorize the inhabitants so they would beseech Gen. George Washington to move troops from the Hudson, an attempt to capture Maj. Ebenezer Lockwood, and an attempt to surprise a regiment of American cavalry that was successful at engaging the British. The raid involved noteworthy individuals who later became major celebrities of the times and succeeded in capturing papers of the extremely successful American spy operation know as the Culper Ring, spy member names, codes, invisible ink, and a list of whaleboats they employed.

Those involved included the British lieutenant colonel Tarleton; Maj. Benjamin Tallmadge, who was one of Washington's spy masters; Col. Elisha Sheldon, who commanded the regiment of American cavalry headquartered at Poundridge and was charged with protecting the northern frontier; Benedict Arnold, who, after saving the American Revolution on more than one occasion, began his betrayal by providing information on the area to the British; Maj. Ebenezer Lockwood of Poundridge, who was in charge of the Bedford/Poundridge militia; and Luther Kinnicutt, who was a master spy for Washington and warned Poundridge of the upcoming raid.

Shortly after the raid, on July 28, 1779, Gen. George Washington wrote to Maj. Gen. Robert Howe, "in case of any movement of the enemy on your right flank by land or water, you are to approach this post in proportion and always preserve a relative position. It is suggested in a Letter from General Glover, that Poundridge would be good position for your corps. I am not certain where this is; but as far as I recollect, it is an intermediate point between Ridgefield and Bedford, which will at once bring the troops nearer to the sound and nearer to this post. If this should be a just idea, I should recommend this place in preference to Ridgefield because it better answers the two objects of covering the country and communicating with the forts and is at the same time sufficiently secure."

The 1800s brought prosperity and growth to Poundridge. Shoe making and basket making where the main occupation of the times for residents. The principal factor in the decline of prosperity and population in the late 1800s was automation that ended basket making by hand and the lack of railroad transportation for freight and passengers. Three railroads were planned to run through town but were abandoned after the financial panic of 1873.

Priceless open space came naturally to Poundridge through its hilly, rocky land and later through the purchase of about 1,500 acres of the town for reservoirs and their buffer zones. Stamford Water Company turned the Round, Middle, and Lower Ponds into Trinity Lake Reservoir in 1870 and 20 years later made Mead Pond into Siscowit Reservoir. Land around the Mianus River was bought by the Port Chester Water Works to supply Greenwich through

the Bargh Reservoir. Unchanged through this period were the stone walls that separated home lots, pastures, and fields and can still be seen in the woods and along the roadsides. They are an integral part of the charm of Pound Ridge and monuments to the pastoral lifestyle that Pound Ridge retained as other towns' density intensified.

By 1900, Poundridge was in an economic tailspin. Land that had been so laboriously cleared in the 18th and 19th centuries reverted to woodland as farms were abandoned when families died out or moved away to find more remunerative work. The post offices in Scotts Corners, Boutonville, and Poundridge Village all closed by 1903, and mail was delivered via New Canaan, Stamford, Bedford, Cross River, and Ridgefield. Life was serene, if austere. Pound Ridge would not have its own post office until 1953. The most dramatic events were fires. One in 1905 burned Fred R. Scofield's general store in the hamlet that had been used for town meetings, elections, and court. After a long dry spell, fires broke out all over town in May 1911. Large areas of town burned for two weeks, destroying abandoned houses as well as meadows and woodlands.

The serenity of Pound Ridge attracted many visitors, and taking in summer boarders helped provide income for local families. City folk began buying up large farms for the back taxes owed on them. Westchester County acquired over 4,000 acres in 1925 and called it Pound Ridge Reservation. Writers, artists, entertainers, and other well-known people bought homes in Poundridge as summer retreats in the 1920s and 1930s, and a significant number made Poundridge their principal homes. Another wave came after World War II.

A few men were crucial to the town's evolution during the first half of the 1900s. George Ruscoe was town supervisor from 1894 to 1927 and a justice of the peace for 62 years, a state record. Everett Knapp, a member of one of Poundridge's old families, was elected town clerk in 1929 and continued in an increasingly demanding post for 32 years. William Shine, who had been an assessor, was supervisor from 1934 through 1959 and bridged the gap between "old" Poundridge and "new" Pound Ridge.

Cleveland-born inventor Hiram Halle owned about 700 acres and restored numerous homes during the Great Depression, providing work for 60 men. The town's library and the Halle Ravine preserve, created by a family gift, are named in his memory.

A descendant of Massachusetts Pilgrim families, Ernest Lee Conant was a lawyer and confidential advisor to Pres. William McKinley on Cuban affairs. After retiring from his law practice in 1936 when he was 80 years old, he bought over 2,000 acres in Poundridge and Lewisboro. He constructed numerous lakes and ponds. Anxious to preserve the natural beauty and forestall overdevelopment, he required those who bought land from him to promise not to resell parcels of less than five acres. The Good Neighbor Awards and Conant Hall perpetuate his memory.

As in all of Colonial America, the church held an important place in the life of Poundridge. It was the center of town spiritual, social, and political life. It was often the only building large enough to hold a town meeting, and there was no objection at that time to the blending of church and state. Since the minister was better educated than most of the townspeople, he usually taught school in addition to his other duties. He was given a modest place to live and the use of a piece of ground on which to raise some of his food but very little in the way of cash.

For a time there were five churches serving the people of Poundridge. The Presbyterian Church was the first church in Poundridge. Its meetinghouse was built in 1760, and the congregation was incorporated in 1788. The British torched the meetinghouse in 1779, and it was rebuilt on the same site in 1786. In 1893, this old building was torn down and a new structure erected as the Reverend Patterson Memorial Church. The former Presbyterian church became Conant Hall in 1949.

Henry Eames brought Methodism to Poundridge. By 1797, the first Methodist meetinghouse was built in Poundridge close to the New Canaan border in an area called Dantown. The Methodist Episcopal Society, incorporated in 1822, constructed a simple church at the junction of Pound Ridge Road and Westchester Avenue in 1833. By 1947, it was called the Pound Ridge Community Church and a south wing was added. The Maj. Ebenezer Lockwood house became

the present parsonage in 1955. Ten years later a narthex and steeple were added to the church. The Pound Ridge Community Church had bought and then turned Conant Hall over to the Town of Pound Ridge as a gift in December 1983.

The first school in Poundridge was held in the Presbyterian meetinghouse with the pastor as the schoolmaster. School district boundaries shifted with population changes so that no child had to walk more than a mile to school. Despite meager formal training, teachers were adept at keeping order within their one-room schools while teaching several different grade levels in sequence. Parents within a school district helped construct the simple buildings. The teachers, whose salaries were minimal, boarded with local families. Students' class work was done on small wood-framed slates, which were easily cleaned and reused. The school year was flexible so as to free the children to help with planting and harvests. In 1939, one-room schools were replaced by the Pound Ridge Elementary School. It was built on land given by Hiram Halle in exchange for village school No. 5, which he later turned into the library.

Poundridge was a pioneer in open space and natural preservation in the 1900s. The 1936 zoning ordinance was a farsighted road map to the town's future. Adopted after three years of town debate, it set minimum lot sizes for residential and commercial structures with a maximum two-acre zoning. In 1957, after a town debate on raising the maximum lot size to four acres, zoning increased to three acres. This was the largest lot size among local towns at that time. A wetlands buffer zone of 100 feet was also established. The fire department bought 32.7 acres on Westchester Avenue and gave it to the town for a park in 1958. The Stamford Water Company created the Mill River Reservoir in 1965, and some of its unneeded acreage was added to the park. That and later acquisitions enlarged the town park to over 50 acres.

In 1969, the town became the first community in New York State to adopt freshwater wetlands protection legislation and to establish a water control commission to administer these regulations. In 1972, the Henry Morgenthau Preserve was created by Ruth Morgenthau Knight and her daughter Ellin N. London. In 1986, the wetlands buffer zone was increased to 150 feet. At the end of the 20th century, the Pound Ridge Land Conservancy took steps to preserve ecologically valuable areas and to provide wildlife sanctuary as it became the town's largest landowner of privately held permanently preserved open space with over 350 acres. Town residents also voted a self-levied land conservation tax for the purposes of buying and permanently preserving open space.

Extensive detail on Pound Ridge history can be found in Jay Harris's *God's Country*, which is 500-plus pages and is available from the Pound Ridge Historical Society.

One

LONG RIDGE TO HIGH RIDGE ROADS

The Long Ridge area extends from Connecticut in the south to the Great Hill at the Bedford border, the Mianus River to the west, and High Ridge Road to the east. Pound Ridge was first settled in the Long Ridge area around 1718 via land grants given to the Stamford, Connecticut, parish. This area was engaged in dairy farming more so than any other part of town. Other industries were hat making, shirt making, and cobbling. Illicit stills accounted for a good deal of income during Prohibition.

It was not until 1928 that electricity came to Long Ridge. The electric company refused to lay power lines because homes were so far apart. The neighbors had to enter into contracts agreeing to pay $4 per month whether electricity had been used or not.

Long Ridge Road, paved in 1921, was and still is the main travel route from Bedford to Stamford, Connecticut. In the 1700s through early 1900s, Bedford and Pound Ridge residents traveled the winding road to bring their goods to the markets and shipping port of Stamford. Today professional workers head to corporations in Stamford and the rail hub to New York City.

In 1950, Long Ridge residents paid their taxes to Pound Ridge, had a mailing address of Stamford, Connecticut, and a telephone exchange of Bedford. The Great Hill section of Long Ridge Road was a dangerous stretch with many accidents. It was straightened in the early 1950s, although there are still several sharp and blind turns.

South Bedford Road, one of the most scenic in town, was the original road from Bedford to the High Ridge enclave of Stamford, Connecticut. Present-day Snake Hill Road was part of this old route.

The Long Ridge area claims many firsts. White Birch Road was the town's first subdivision in the mid-1900s. Mianus River Gorge was the first site preserved by the Nature Conservancy in 1954. In 1964, the gorge became a natural history landmark. Also, the United Nations site selection committee narrowed its focus to two locations, one being the Long Ridge area Ye Great Meadow. It is said that the strong opposition in Pound Ridge helped persuade the site selection.

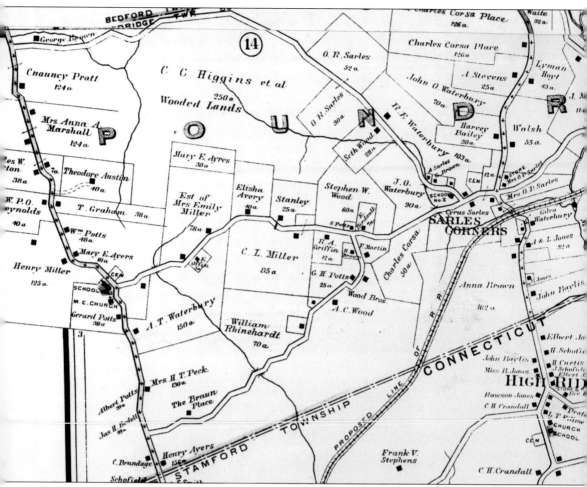

A 1906 POUNDRIDGE MAP. In this 1906 map, a proposed railroad is shown cutting across Pound Ridge. What a different place Pound Ridge would be had the rail line been built. Long Ridge Road was named "the Road to Stamford through Pound Ridge" in 1797 and Bedford Village Road (county road No. 3) prior to 1940. Also, prior to 1940, Upper Shad Road was Maple Avenue and Lower Shad Road was Pine Grove Avenue.

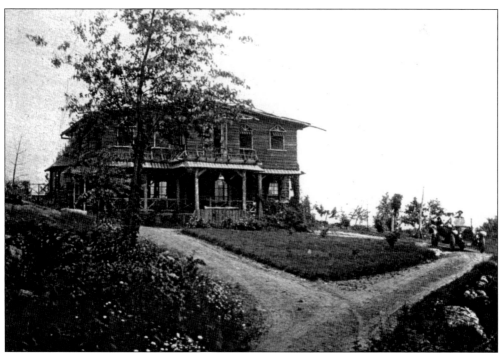

KENDALL HOME. The Kendall estate comprised over 225 acres and today is the prestigious Rock Rim Ponds estate home sites along with 40 acres of permanently preserved woodlands and wetlands. The original home no longer exists. Florence Kendall, at the age of 67, purchased, equipped, and drove an ambulance during World War I in France, where she became known as "Lady Florence."

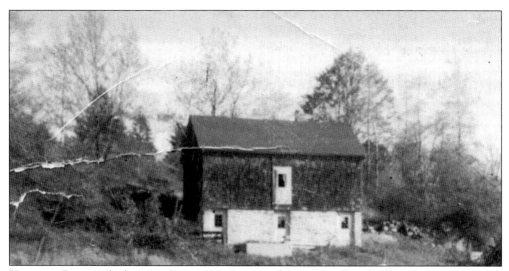

KENDALL BARN. The barn in this *c.* 1910 photograph was part of Kendall's working farm. Today it is a residence on Lower Shad Road.

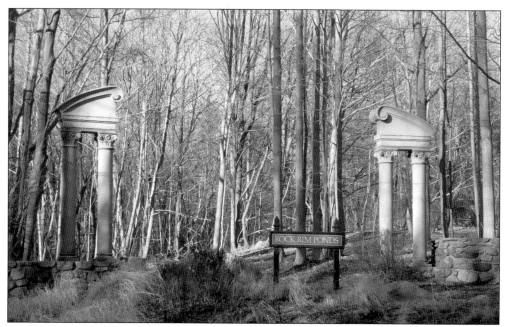

KENDALL COLUMNS. The stone pillars on the corner of Long Ridge Road and Lower Shad Road once led to the former Florence Kendall property and were brought from Europe on one of Kendall's many trips abroad. (Courtesy of Vince Manna.)

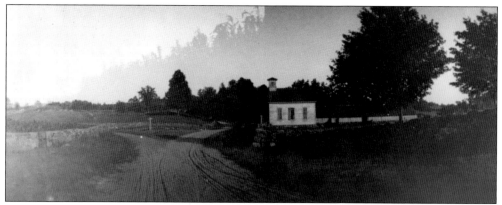

GREAT HILL EPISCOPAL CHURCH, 1908. Nearby the intersection of Upper Shad Road and Long Ridge Road was the Great Hill Episcopal Church. This building is no longer standing.

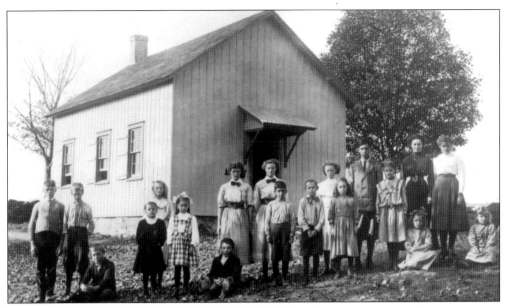

GREAT HILL SCHOOL. At the intersection of Upper Shad Road and Long Ridge Road is the former Great Hill School, built in the early 1800s and one of the five elementary schoolhouses in the town at that time. It is now a private residence (red home as of 2009). The above photograph is the oldest known image of the school and dates from 1900 and is a wonderful example of the age differences in the one-room schoolhouse. Note the older girls with their bow ties, standing in the center, and the youngsters to their left. The teachers are on the right. The photograph below is believed to have been taken during the 1930s depression, when the town population dwindled. The landscape behind the children is looking east on Long Ridge Road and shows the dairy farms.

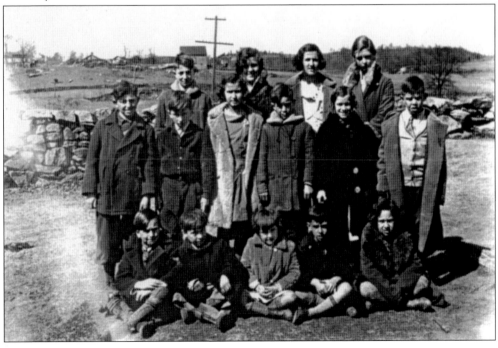

SIMEON DIBBLE HOUSE. This home is one of the oldest in this area. Simeon Dibble owned an extensive farm on Long Ridge Road. The house is thought to be pre-1776. Jonathan, his father, was listed on the 1777 roster of Poundridge patriots. Simeon was Poundridge's only War of 1812 veteran. The right wing of the house is the 1700s section; the left side is from the 1800s. It has a fireplace in nearly every room.

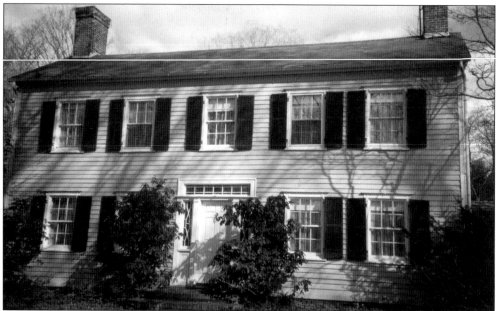

JOSEPH AMBLER HOUSE. Joseph Ambler inherited 125 acres from his father, Benjamin, in 1811 and probably built this Long Ridge Road house after he married in 1825. He resided there until 1836, when he sold the house and property to Larry Robertson. A pristine example of late Federal style, the structure contains a central stairway and brick chimneys on each end wall. Four fireplaces grace the rooms.

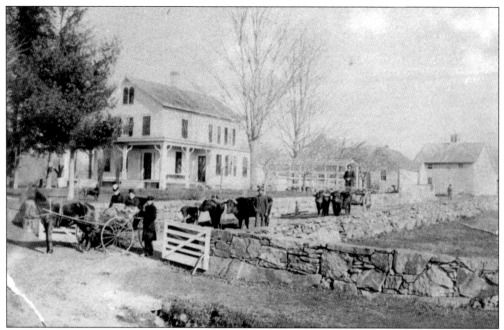

BISHOP/MILLER/MAAS HOME. This home may have been built in the late 1700s. Daniel Miller of North Castle purchased this property from John B. Bishop on March 19, 1784. An 1817 survey of this house and property with adjoining land was made for Daniel Miller on March 21, 1817, by Ezra Lockwood of Poundridge.

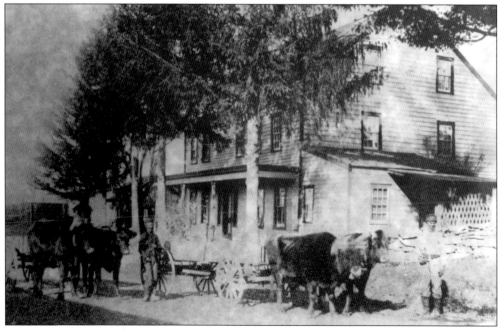

WATERBURY FARM. This pre-Revolutionary house on Long Ridge Road was once a tavern on the stagecoach line between New York and Boston via Danbury. The taproom was on the first floor. The first Waterbury to own the farm purchased it in 1852. The chimney serves three fireplaces. Long Ridge Road originally ran on the eastern side of this home.

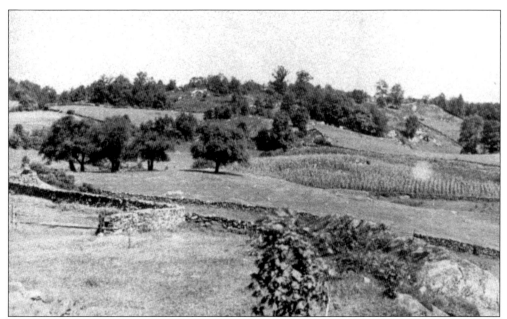

GREAT MEADOW SOUTH. This wonderful series of photographs, taken from the east side of Long Ridge Road between Lower Shad and Waring Roads looking westerly, forms a unique collection of what the Great Meadow community was like around 1935. A small airstrip, bridle trails, and footpaths were all that intruded on fields used for dairy farming. The photograph shows open fields for grazing and numerous stone walls made with stones from the fields themselves.

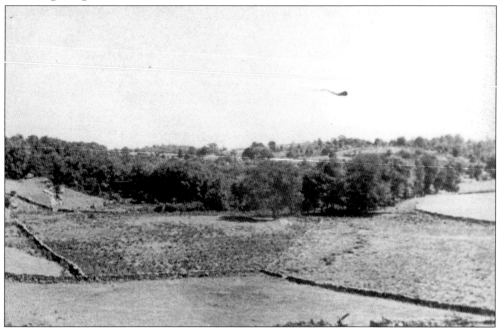

GREAT MEADOW AIRSTRIP. Much of this area was unchanged from the mid-1800s through the 1930s. The land lying to the west, also known as Ye Great Meadow, was still undeveloped. Behind the tree line was a small airstrip, as is indicated by the streamer in the skyline. The farm homes lining both sides of the road date back 100 to 300 years.

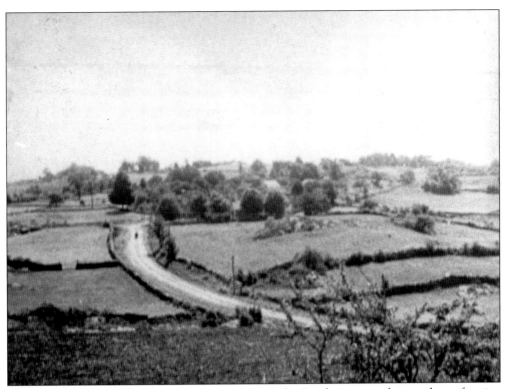

YE GREAT MEADOW. The Great Meadow on Long Ridge Road was a vast dairy and crop farming area. It is said to be the largest contiguous dairy farming area of Pound Ridge. The photograph above shows Long Ridge Road pictured in a southerly direction. The photograph below shows fields and Long Ridge at the bottom near the pole that is at the bottom of the hill. At one time, most of this land was owned by the Percival White family.

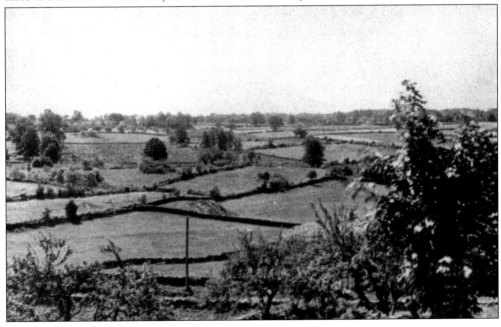

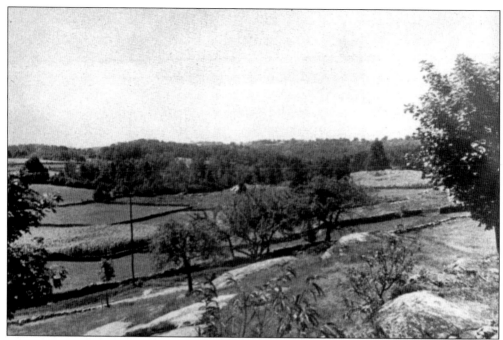

GREAT MEADOW NORTH. In the photograph above, Long Ridge Road is tucked in front of the flagpole. The left-to-right travel is south to north.

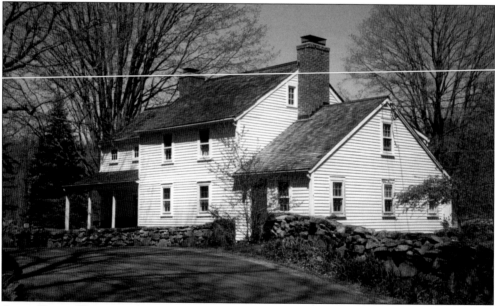

AMOS DIXON HOME ON LOWER SHAD ROAD. Betsey, a daughter of Jesse Hoyt born in 1774, married a John Clock. In 1821, Jesse Hoyt and his wife Lydia sold to John Clock of Poundridge three roods of ground (three quarters of an acre) for $10. In 1825, John Clock and his wife Betsey sold this property to Isaac Jones of Stamford for $175. The deed specifically mentions a dwelling house, which indicates that John Clock built the house after his purchase of the land. Amos Dixon purchased the house in 1829 for $187. He lived in this house until his death in 1862. His son Zophar Dixon owned the house at one time, as did his grandson George E. Dixon.

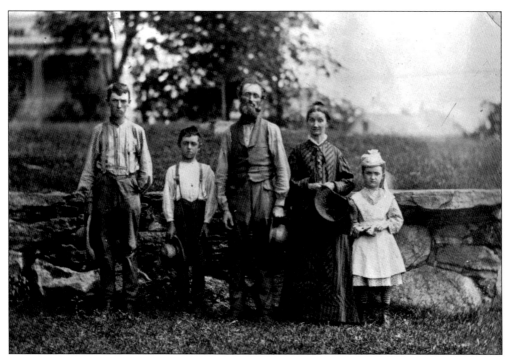

SUNDAY'S BEST CLOTHES. This unidentified Pound Ridge family is posing in their Sunday-best outfits.

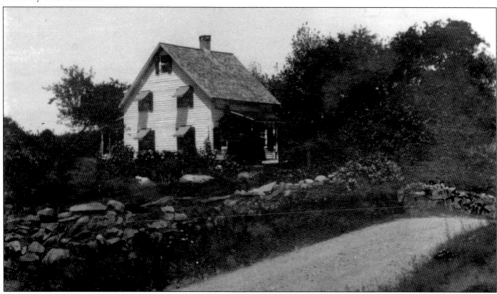

JESSE AND CHRISSY HOYT HOME. The Hoyt family owned much of the land on both sides of Upper Shad and Lower Shad Roads. This land was handed down from the original 1685 Stamford patent landowner Joshua Hoyt. Jesse Hoyt was born in 1743 and was living in Poundridge at the time of Banastre Tarleton's 1779 raid. Thus, this home must have been built sometime before that. A. Waterbury held ownership from 1866 to 1881. Wallace Widdecombe and Jane Houston (played the mother of Stella Pallas on radio) bought the house in 1927. (Courtesy of Alice Hand.)

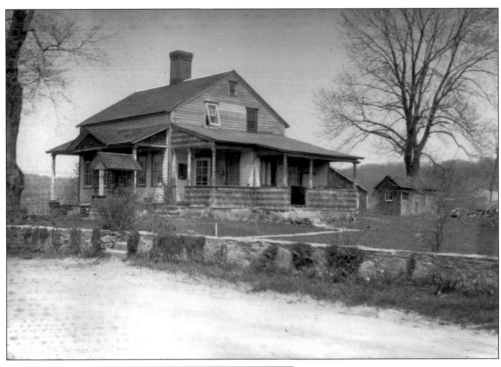

EBENEZER JONES HOUSE AND CHICKEN COOP. This South Bedford Road house was owned by Ebenezer Jones, a shoemaker. Construction details indicate that the house may have been built around 1770. It has no ridgepole in the roof; there are very old beams in the attic that show they have been reused; and it has a beehive baking oven next to the main fireplace. It was probably modified around 1815–1820, judging by the fact that the front door sidelights are "blind" because they are in front of beams. There are three fireplaces in this center-chimney, one-and-a-half story house. A smokehouse is shown to the right of the home. The cottage behind the house was originally a one-story shoemaker's shop, located next to the house. Ebenezer Jones, his two wives, and his children are buried in a private cemetery on Upper Shad Road. (Courtesy of Josina van der Maas.)

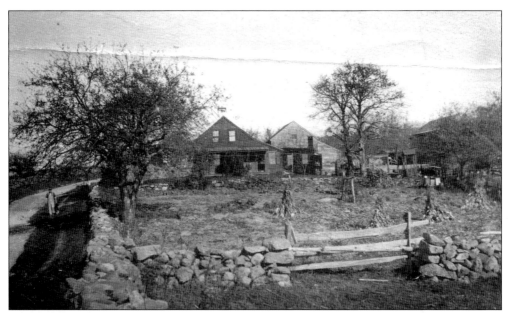

SOUTH BEDFORD ROAD HOME. Both the Ebenezer Jones photograph and this one were given to the historical society by the same owner. This picture is believed to be of an adjacent farm.

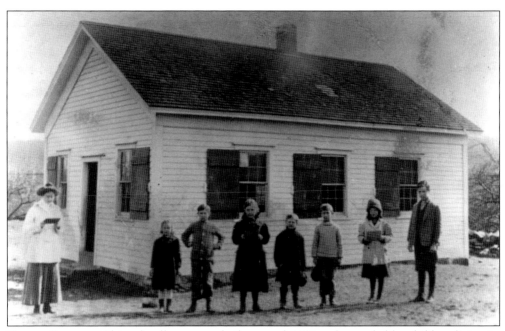

PLAINS SCHOOL. This schoolhouse was built around 1850 and attended by children living in the South Bedford Road area. It was converted to a home after the one-room school system was replaced with one central Pound Ridge school in 1939.

SAMUEL SEELY HOUSE. The Seely family settled on what is now High Ridge Road in the late 18th century. Samuel Seely, born in 1763, is mentioned on the 1798 road list, and an 1806 deed refers to an existing house on Seely's property. These two facts indicate a *c.* 1800 date for his home. This center-chimney landmark is a full two-story house with an attic.

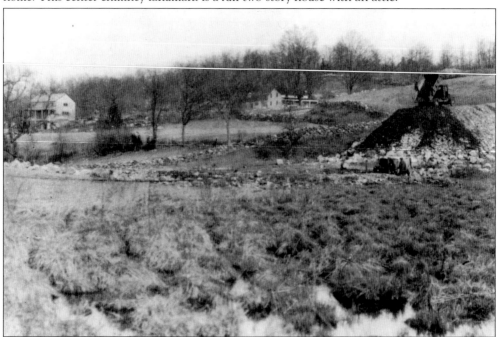

BUILDING HIGH RIDGE ROAD. This photograph shows the construction of High Ridge Road cutting across open fields. This roadway cut Snake Hill Road in two and was a more direct route. Snake Hill Road literally snaked around a large hill.

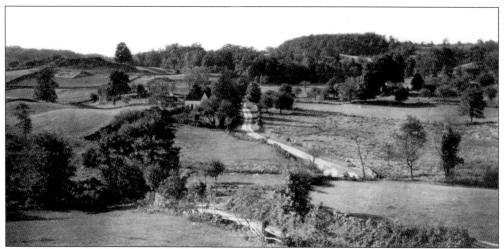

SNAKE HILL ROAD. This view is looking north on Snake Hill Road before the southern part of High Ridge Road was built. Prior to 1920, the southern part of High Ridge Road included the present-day Snake Hill Road. In the 1920s, High Ridge was reconfigured to eliminate a dangerous hill. The eastern section is now called Snake Hill Road. A small portion of this Revolutionary-era road exists today as a dirt road west of High Ridge just before Upper Shad Road.

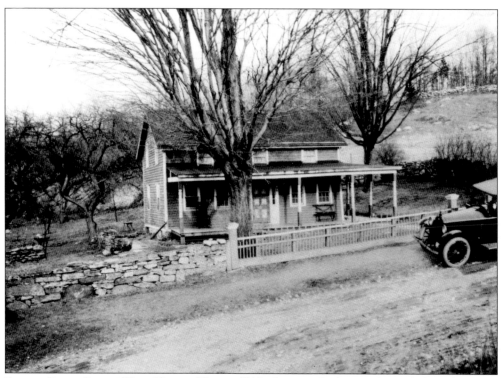

SARLES-BODE SNAKE HILL HOME. This *c.* 1920 photograph shows a home believed to have been built by the Sarles family. The Bode family purchased the home and took this picture. Note the cleared fields in the background, which is in sharp contrast to today's wooded home sites.

SARLES-BODE BARN. The Bode family moved this barn 100 feet and converted it into a home, which still exists. The intersection of High Ridge Road and Upper Shad Road was known as Taylor's Corner in the 1850s and Sarles Corner starting in the early 1900s.

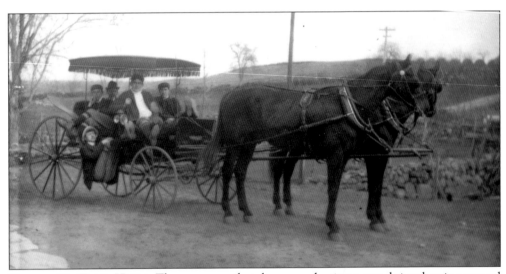

KICKING UP THEIR HEELS. These men on their buggy are having a grand time horsing around (in more ways than one). Note the cleared fields in the background, which are in stark contrast to today's Pound Ridge wooded landscape.

Two

POUND RIDGE VILLAGE

The historical center of town, Pound Ridge Village, is known today as "the Hamlet." The phrase was coined as a real estate marketing term in the early 1940s. While Pound Ridge Village is more fitting and historically correct, the term "the Hamlet" endures. The pre-1940s spelling of Pound Ridge is as one word with a small r, as evidenced on numerous maps.

This section of town functions as the cultural center and contains the elementary school, library, museum, a small number of commercial establishments, and many residences. Thankfully, a planned business district, Scotts Corners, moved development away from this historic section. All town master plans since have called for no commercial or residential expansion of Pound Ridge Village.

In 1760, the Pound Ridge Presbyterian Church passed a resolution to build its meetinghouse at the site of Burial Hill, now the Pound Ridge Cemetery. The church changed its mind and built the first meetinghouse at the site of the present Conant Hall on land donated by the Lockwoods. In Colonial days, a church was the focal point of a community. This original plan for a church on West Lane would seem to indicate the concept of a town center in this area in the 1700s. In addition, the home of the pastor was the present building of the town house maintenance headquarters. It is interesting to note that the Lockwood family land holdings during the mid-1700s consisted of some 500 acres from West Lane to Salem Road, which today encompasses the cemetery, town park, and the hamlet to the library.

By the early 1900s, there were four houses and a blacksmith shop in the West Lane area. The Pine Terrace Center, located on the current town house property, was part of the original Presbyterian Church parsonage. West Lane is referred to in old deeds as the "main road to New Canaan from Bedford."

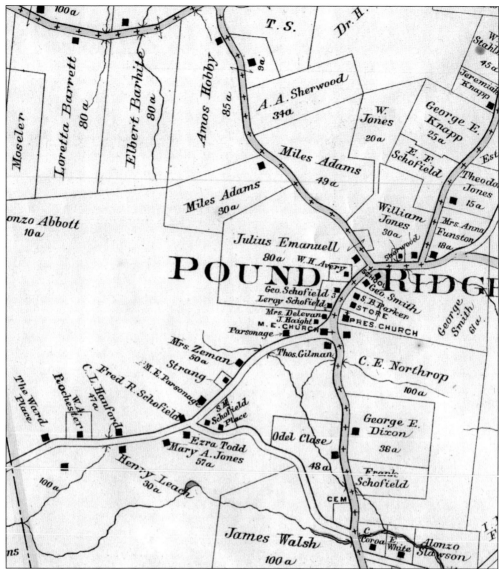

POUNDRIDGE VILLAGE MAP, 1906. In her book *God's Country*, Jay Harris states that the road exiting Poundridge Village to the northwest, Stone Hill Road, did not exist until 1799. When the British raided Poundridge Village during the American Revolution, they needed to travel a circuitous route farther east on Old Stone Hill to Salem Road and then headed southwest. However, there is some evidence that this road did exist at the time of Banastre Tarleton's raid, and Tarleton entered the village in the area of the present-day Hiram Halle Library. One must remember that the village at that time consisted of two or three houses, a small store, and the Presbyterian church.

28

NATHAN OLMSTEAD HOUSE. This is the first home along Pound Ridge Road from Bedford and was probably a typical one-and-a-half-story house when built. Nathan Olmstead was listed on Maj. Ebenezer Lockwood's 1777 roster of Poundridge patriots. In 1813, Olmstead sold the 100-acre property to his son-in-law David Hobby. The house was a halfway stop on the Danbury–White Plains stagecoach line. In the 1930s, the building was the site of a French restaurant.

HIRAM KEELER HOUSE. This home was built around 1835 and sold for $500. Just north of this house there is a stone wall matching the description given by Ezra and Betsey Lockwood in an 1844 interview. They mention that in July 1779, Maj. Henry Leavenworth was stationed with a body of 100 Continental troops along a wide stone wall "about a mile from Poundridge on the lower road."

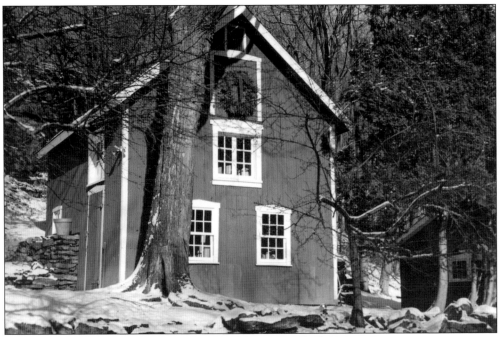

HIRAM KEELER BARN. This barn was part of the Hiram Keeler property.

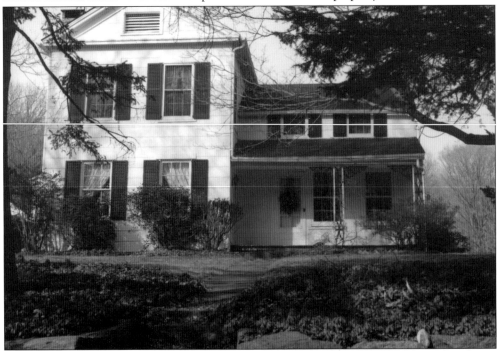

METHODIST EPISCOPAL CHURCH PARSONAGE. The Methodist Episcopal Church (now the Pound Ridge Community Church) built this house for its minister in 1851, possibly utilizing the foundation and/or remnants of a house previously owned by Stephen Thatcher. The cottage to the left of the house was built on the foundation of Stephen Thatcher's shop. The church sold the property during the Depression.

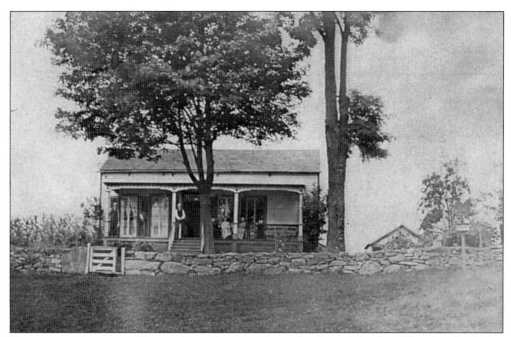

PARTRIDGE THATCHER HOUSE. Partridge Thatcher, a brother of Stephen Thatcher, built this house around 1789 (the photograph above was taken around 1890). This was probably at the time of his marriage to Mary Lockwood, daughter of Ebenezer Lockwood. The building was originally a small center-chimney house with two fireplaces and a sleeping loft. The Thatchers raised 10 children in this small house of three rooms and a sleeping loft. This house with one half acre sold for $198.75 in 1815 and for $300 in 1903. Note the original stone wall is still intact, and the tree to the right of the house has grown significantly in the last 100 years.

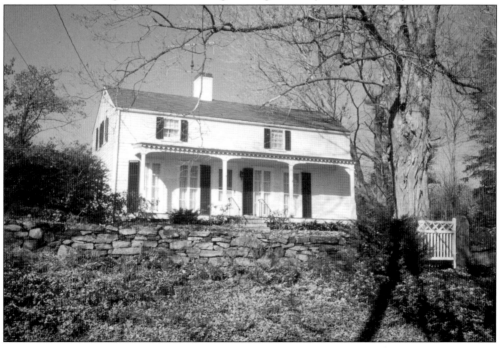

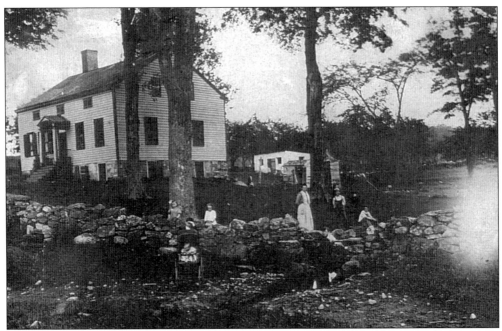

BETSY LOCKWOOD HUNT HOUSE. Betsy Lockwood, the oldest daughter of Maj. Ebenezer Lockwood, married Alsop Hunt from New York City in 1777. She was not quite 15; he was 30. Legend relates this early Georgian-style farmhouse was built by Ebenezer Lockwood upon the marriage of his daughter. However, research cannot confirm this early date. Alsop Hunt was taken prisoner by the British during Banastre Tarleton's raid in 1779 and imprisoned in New York City. After the Revolution, the Hunts lived in New York City, where Alsop was a successful merchant. There are two chimneys and six fireplaces in this center-hall house. Betsy returned to Poundridge in 1824 as a widow and lived out her days in this home. (Courtesy of Richard Major.)

ALICE IN DAD'S BUGGY. Alice Tomlinson is pictured in her father's buggy.

GYPSY TEA ROOM. Helen Janin Smith owned the Betsy Lockwood Hunt house in the 1930s. During that period, she moved a building to this site and operated the Gypsy Tea Room on the premises. In the 1940s and 1950s, a local milk distributor used the building as a transfer center and then as a private residence.

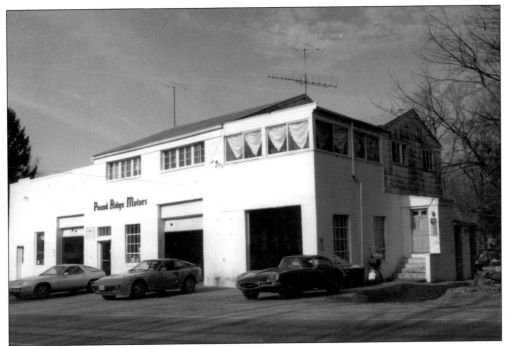

POUND RIDGE GARAGE. Helen Janin Smith built a garage on this site in 1936. Her son, Jaques Smith, operated the business until it was sold to Clarence Bouton in 1946. It still functions today as an automobile repair shop.

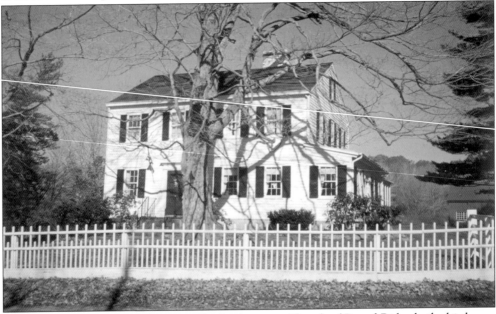

REV. WILLIAM PATTERSON HOUSE. The Presbyterian Church of Pound Ridge built this house for its new minister, William Patterson, in 1836 on land donated by Betsy Lockwood Hunt and her brother Ezra Lockwood. Reverend Patterson married Sarah Thatcher, one of the 10 Thatcher children, the same year. He died of pneumonia contracted during pastoral rounds in the blizzard of 1888. In 1933, the house was sold to Hiram Halle.

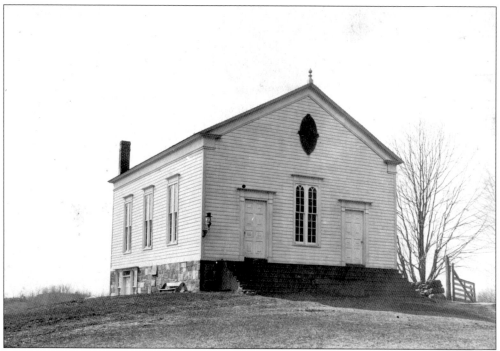

METHODIST EPISCOPAL CHURCH. Horatio Lockwood's brother, Judge Ezra Lockwood sold a quarter-acre lot west of his residence to the Methodist Episcopal Church in 1833. The church, built on a stone foundation, had wooden steps leading up to the two entrance doors. A rear section was added in 1947, when the church was renamed the Pound Ridge Community Church. The steeple and narthex were 1965 additions; the parish wing was built two years later.

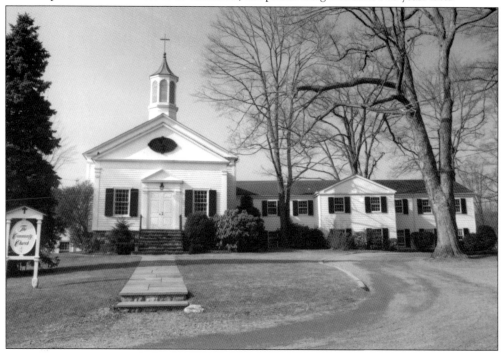

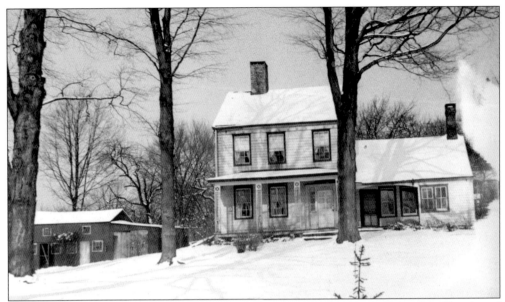

EZRA LOCKWOOD HOUSE. Judge Ezra Lockwood, son of Maj. Ebenezer Lockwood and brother of Horatio, probably built the original section of this house when he married in 1798. The original section of the house, right side of the photograph, comprised one large room, a pantry under the stairs, and a sleeping loft. The large two-story addition is 19th century. The house later became another Hiram Halle renovation. Ezra was town supervisor from 1807 to 1819 and judge of the court of common pleas.

LEWIS LOCKWOOD STORE. Judge Ezra Lockwood sold this building to his son Lewis Lockwood in 1853. The original construction date is unknown, but an 1851 map of Poundridge shows a store at this location. From 1872 to 1946, the house was a two-family residence. The building also housed the first kindergarten class in Pound Ridge.

MAJ. EBENEZER LOCKWOOD HOUSE. Maj. Ebenezer Lockwood commanded the local militia during the American Revolution and allowed his home to be used as headquarters for Col. Elisha Sheldon's cavalry regiment. The British destroyed his home during Banastre Tarleton's raid in 1779. He rebuilt his home, which is believed to be the rearmost section of the residence on the Pound Ridge Nursery property. This home has two fireplaces on the first floor and a large fireplace in the basement. The more elegant front section was likely constructed by Ebenezer's son Horatio Lockwood around 1830. Ebenezer Lockwood served many terms as supervisor of Poundridge before 1800. His son Horatio was frequently elected to the same position in the early 1800s, as was his grandson Alsop Hunt Lockwood in the mid-1800s. After Horatio died in 1853, his son Alsop Hunt Lockwood became the owner of the house. He sold it in 1871.

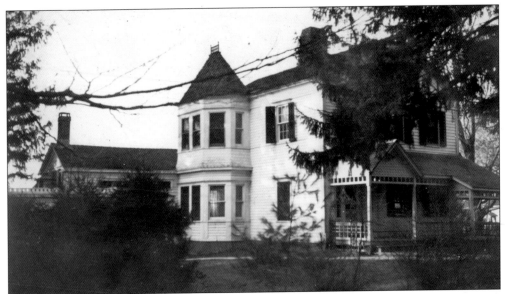

ALSOP HUNT LOCKWOOD HOUSE. In 1836, Alsop Hunt Lockwood, son of Horatio Lockwood, built this house on land his father purchased three years earlier. Ten years later, Alsop purchased the property from his father. Subsequent owners of the house included Leroy Scofield (1880–1919) and town supervisor George I. Ruscoe (1919–1923). Ruscoe would travel to the yearly supervisors' meeting in White Plains by walking from Poundridge Village to the New Canaan train station, disembarking at Port Chester, and walking to White Plains. In the late 1930s, the building became the Dexter Lodge. Hiram Halle then purchased and remodeled the structure and persuaded Emily Shaw, an experienced restaurateur, to operate an inn and restaurant on the premises. The inn was discontinued, while several additions enlarged the restaurant, named Emily Shaw's Inn. In 1989, Dorothy Treyball purchased the property, renaming it the Inn at Pound Ridge.

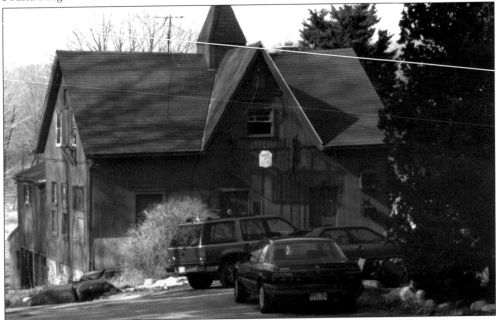

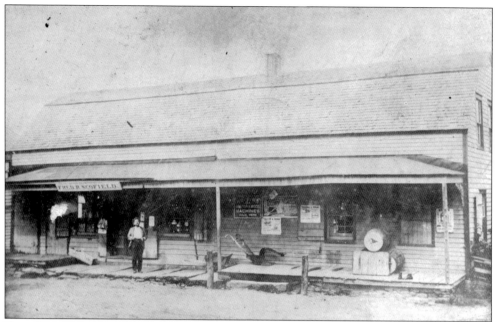

FRED R. SCOFIELD GENERAL STORE. This general store was first started by William Smith. Fred Scofield, pictured, purchased it from him and operated a thriving business. The building was located just north of Alsop Hunt Lockwood's home (now the Inn at Pound Ridge/Emily Shaw's). Fire destroyed the building in 1905.

SOME 1930s FUN. This 1930s photograph shows an unidentified Poundridge family in an older section of their home.

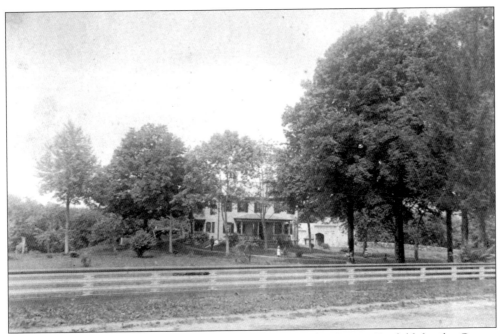

WILLIAM SMITH HOUSE. These 1887 photographs show the George Scofield family: George is standing; his wife Sarah is sitting on the rocker; and little Dee with the doll carriage and daughter Belle are sitting on the bench having some tea. William L. Smith was a grandson of Capt. Joseph Lockwood (Maj. Ebenezer Lockwood's brother). He built this home about 1829, when his mother, Prudence Lockwood Smith, sold him an acre and a half of land. William married Clarissa Thatcher, one of the 10 children of Partridge and Mary Thatcher. He was town supervisor from 1854 to 1855. Also, William is said to have been the first Pound Ridge citizen to embrace the popular temperance movement with enthusiasm. George Scofield purchased the home from William Smith.

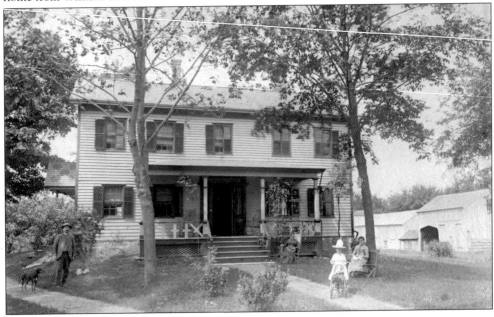

BEFORE HALLE RENOVATION OF SMITH HOUSE. This photograph was taken during the Great Depression of the 1930s and shows the William Smith home before Hiram Halle renovated it. Hiram Halle purchased the property in 1934 and removed the Victorian embellishments. Note that the barn structure has changed since the 1887 photograph on the previous page.

AFTER HALLE RENOVATION OF SMITH HOUSE. This 1960s photograph shows the home after Hiram Halle renovated it. Note that the extensive porch was removed. Hiram Halle disliked porches and removed them from all his restorations.

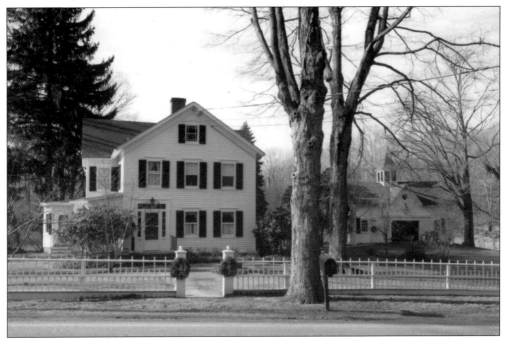

JAMES STAPLES HOUSE. In 1861, the town assessed James Staples for three acres of land. This probably included a house since the assessment was relatively high. An 1867 deed specifically makes reference to the Staples house. The photograph on the next page shows this home.

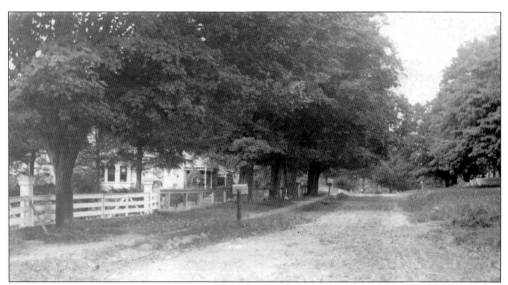

MAIN STREET AROUND 1900. This photograph is what is now Westchester Avenue in the center of Pound Ridge Village and is believed to be looking north from the James Staples house at the William Smith property line. Capt. Joseph Lockwood's home is on the right. Today this section of road is just north of the Samuel Parker Deli and Emily Shaw's Inn.

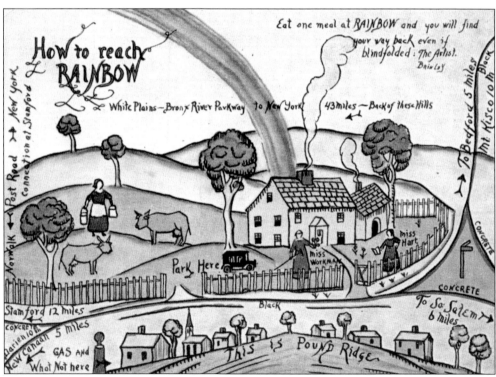

RAINBOW TEA HOUSE ADVERTISEMENT. This advertisement was used both for marketing and as a postcard.

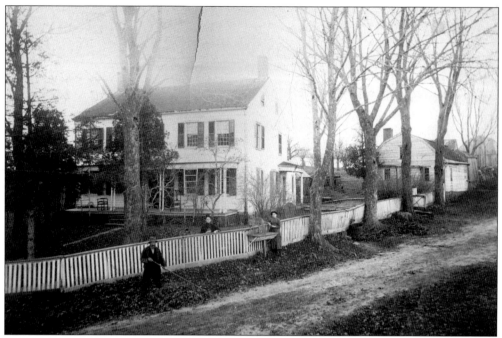

SOLOMON LOCKWOOD HOUSE AND TAVERN. Solomon Lockwood, son of Capt. Joseph Lockwood, probably built his house in 1790, the year he married. This home was one of the few center-hall structures in town. It was located on what is today Westchester Avenue and Stone Hill Road. Four rooms were built off the center hall, and two chimneys stood on each side of the house. An 1827 document refers to Solomon Lockwood as an innkeeper. His own will (1841) refers to his "mansion house."

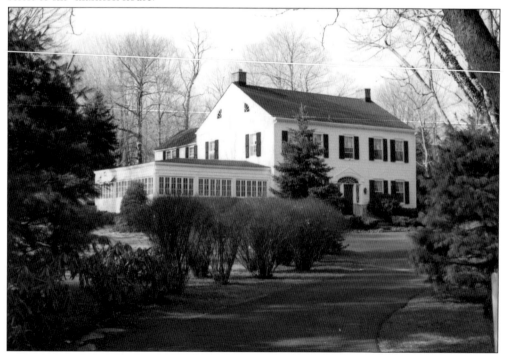

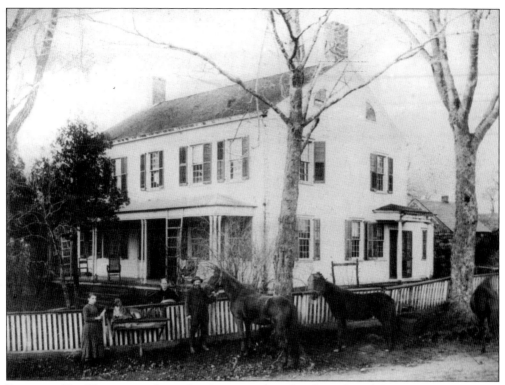

RAINBOW TEA HOUSE AND SHOP. In 1868, Daniel Rockwell purchased the Solomon Lockwood House. The artist Norman Rockwell, his young nephew, is believed to have occasionally visited. In the late 1930s, the property was the site of the Rainbow Tea House and Shop; profits went to the Association for the Aid of Crippled Children in New York City. In 1959, it was considered for use as the town hall.

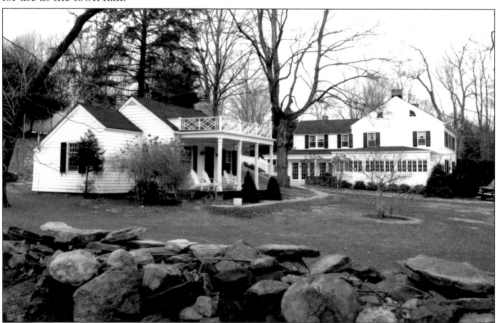

ALICE TOMLINSON DURING FALL. This photograph is of Alice Tomlinson, a resident of the Poundridge Village area.

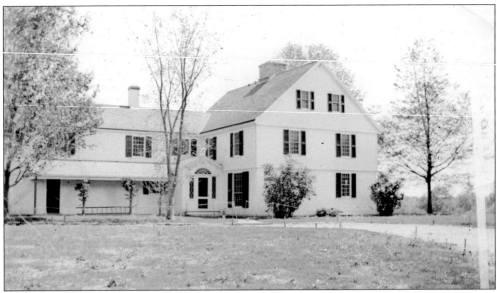

STRATTON HOUSE. This photograph shows the home just after Hiram Halle restored it. This house stood on land in Hartland Hollow, Connecticut, which was condemned for destruction in 1935 after the Connecticut state legislature decided to create a reservoir for the city of Hartford on the site. Hiram Halle purchased the home and moved it to Poundridge.

MAIN STREET, 1906. These 1906 photographs are of Westchester Avenue just north of Pound Ridge Road. Above is a northerly view, and below is the reverse-angle southerly view. Webster Avery's home is on the right in the photograph below, judging by the fencing and hitching posts. Today this section of road is south of the library.

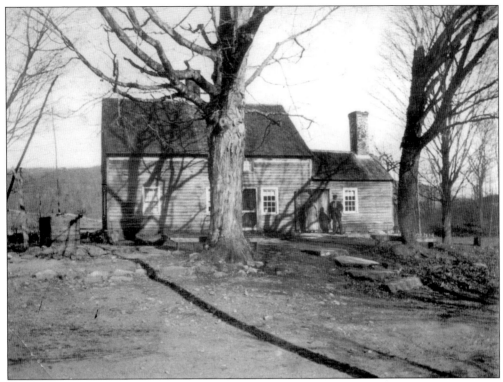

ELBERT BARHITE HOMESTEAD. This home is on the north side of Stone Hill Road and comprised 80 acres. The photograph is from around 1900 and is a southerly view.

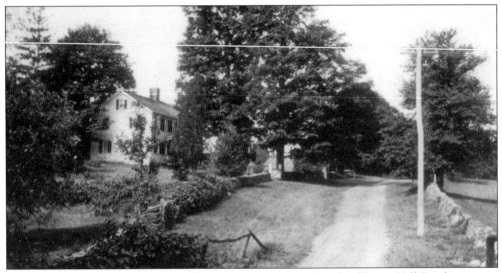

LORETTA BARRETT HOMESTEAD. This house is on the south side of Stone Hill Road, just west of the Barhite homestead. During the 1800s, the estate was 160 acres. At the time of this *c.* 1910 photograph, it was 80 acres. This is a westerly view. The dirt road is Stone Hill Road, which was then called the North Road. It was the main road from Bedford to Ridgefield, Connecticut.

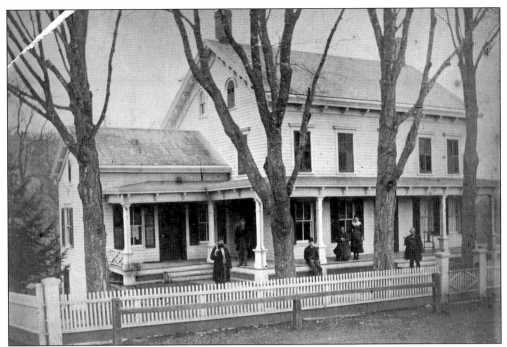

JONATHAN SCOFIELD, HEZEKIAH WOOD HOUSE. This 1881 photograph is of a home on Stone Hill Road. The leftmost portion of the house was the original home built by Hezekiah Wood in the late 1700s. He sold the property in 1793 to Jonathan Scofield, and it remained in the family's hands until 1867, when it was sold to Lewis Green. The authors believe the large section was added by the Scofields. The property was purchased in 1909 by Eugene Myer of the *Washington Post.*

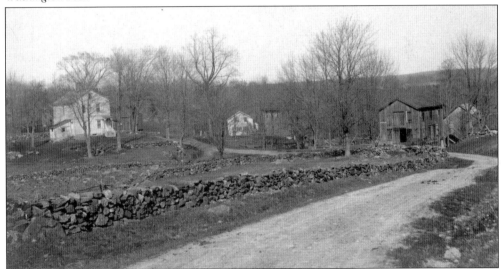

SALEM ROAD. This rare photograph shows Salem Road around 1910. The leftmost home belonged to Horace Reynolds. The middle white home is the William Lockwood house. The home just to the right of that is the Aaron Woods home. The rightmost home is believed to be the Gun House. Today this area of road is traveling east on Stone Hill Road approaching the triangle, then left onto Salem Road. Pound Ridge Village would be to the right.

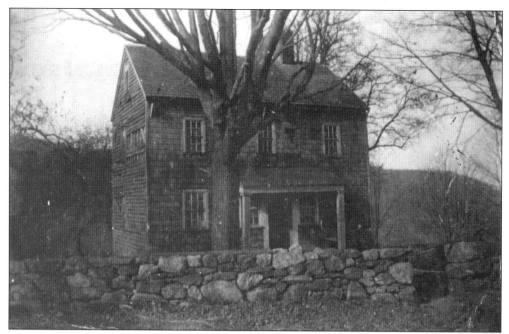

GILMORE/HAUG HOUSE. This home stood on the west side of Salem Road about halfway between Poundridge Village and Boutonville. Charles Haug and his family rented the house from William Gilmore, who had accumulated large land holdings in this section of town. The house was torn down in the mid-1900s.

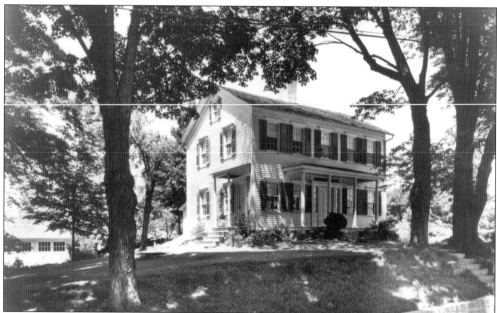

HORACE REYNOLDS HOUSE. In 1840, Horace Reynolds, a blacksmith, married Mary Lockwood. In the same year, Solomon Lockwood sold Reynolds a three-quarter-acre parcel of land for $100. Reynolds sold the parcel the following year to John Waterbury for $1,200. Tradition has it that Reynolds joined the 1849 California Gold Rush, but he must have done so after 1850 because the 1850 census shows Reynolds and his wife living in her father's home.

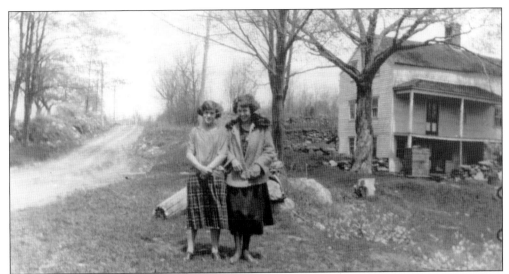

MERCY WARING HOUSE. This is one of the oldest homes in Pound Ridge. Mercy Waring, daughter of Capt. Joseph Lockwood, is the first known owner of record (an 1809 mortgage deed). Pictured are Mabel Williams (left) and Caroline Marshall. This is the only house in Pound Ridge Village with a Colonial bake oven in the rear of the fireplace instead of on the side, an early-1700s phenomenon. This arrangement predates the side oven. A 1740 deed states John Tyler sold a house, presumably this landmark house, to Mercy's grandfather, Joseph Lockwood, and his brother Israel. Tyler himself had purchased the dwelling house in 1737. Thus, the house in all likelihood dates from at least 1737 and is probably even older. In the 1930s, the house became another Halle renovation.

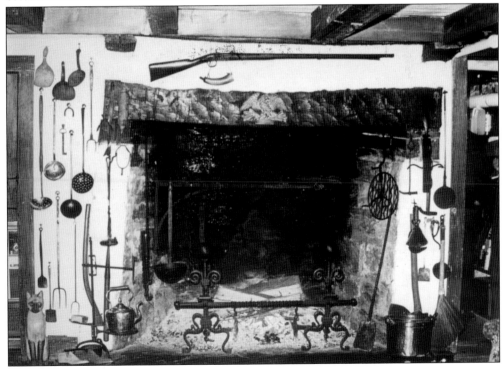

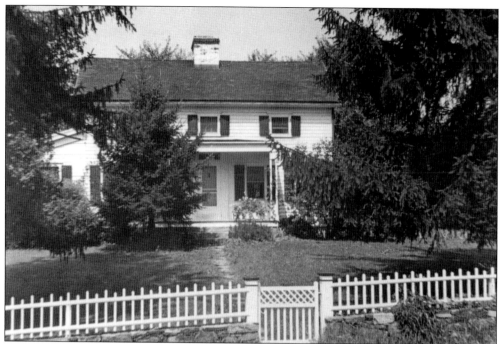

ODLE LOCKWOOD HOUSE. Odle Lockwood (1793–1873) was a son of Solomon Lockwood. He inherited land from his father in 1841, and the authors expect that the house was built then, if not earlier.

ELISHA BROWN HOUSE. In 1850, William Lockwood sold a quarter-acre parcel of land to Elisha Brown. According to the 1850 United States census, Brown, who was a tailor, owned $25 worth of real estate and lived with his wife and young daughter in John Harford's house farther north on Salem Road. In 1852, Brown was assessed for a house and lot, so presumably he built his house between 1850 and 1852. He mortgaged his property several times, once to Alsop Hunt Lockwood. In 1862, Brown sold his property to Edwin Adams. The house is another Hiram Halle renovation.

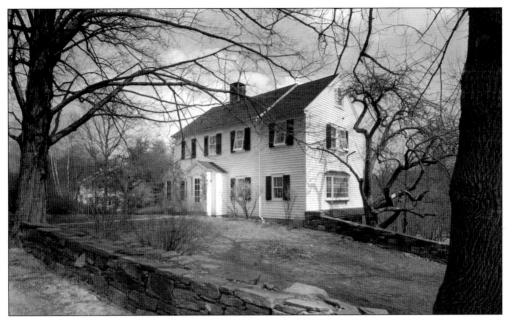

WILLIAM LOCKWOOD HOUSE. In 1838, William Lockwood purchased an acre of land from his cousin William Smith for $150. In 1842, Lockwood sold to Milo Peet for $550, with the deed specifying a sawmill and shop. In 1846, Peet sold to Elihu Dan for $750, and the deed added a dwelling house. The property reverted to William Lockwood in 1848. In 1870, Elihu Dan sold to Aaron Wood, who operated the sawmill.

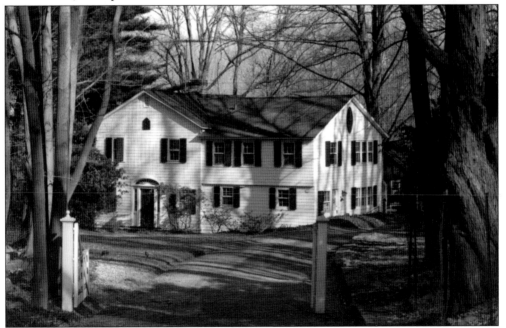

THE GUN HOUSE. In 1841, William Lockwood and Milo Peet quitclaimed a portion of their properties to New York State "for the sole purpose of building a gun house for the company of artillery." It stored the one gun the local militia had. The gun house itself has long since disappeared.

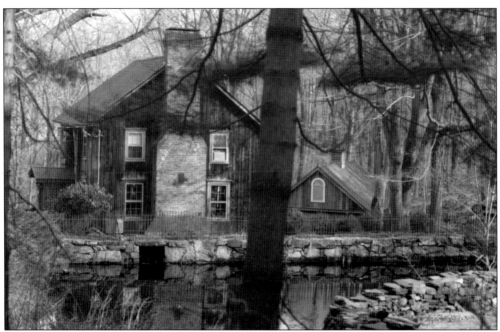

AARON WOOD MILL. The Pound Ridge Historical Society is very fortunate to have these photographs of such a unique structure. This structure still stands today, and the stream still flows under the home. The 1980s picture above shows the pond where water accumulates before flowing into the mill. The 1930s picture below shows the exit path of the water. Capt. Joseph Lockwood owned this mill site, which at that time (late 1700s) housed a cider mill. In 1793, the year after Capt. Joseph Lockwood died, his heirs quitclaimed their shares of the property to his daughter, Prudence Lockwood Smith, with the deed specifically referring to the "Cyder Mill & the Cyder Mill House."

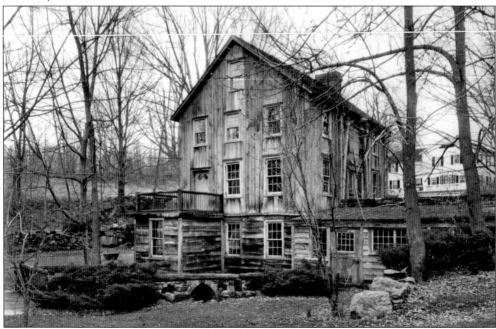

AARON WOOD MILL'S STREAM. In 1842, when Capt. Joseph Lockwood's grandson William Lockwood sold the property, the deed specified a sawmill, rather than a cider mill. Aaron Wood, who purchased the property in 1870, operated a sawmill on the site. In the 1930s, Hiram Halle purchased and totally modernized the building. It became the meeting place for the faculty of the New School's University in Exile, which Halle initially underwrote to help the teachers and scientists who had fled Nazi Germany. The 1930s picture at right shows water flowing out from under the home. The 1980s picture below shows the bridge (see previous page) and stream view.

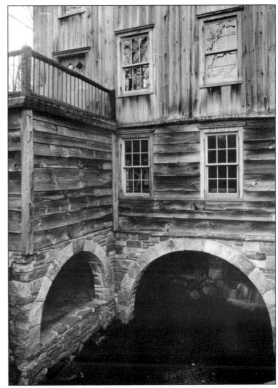

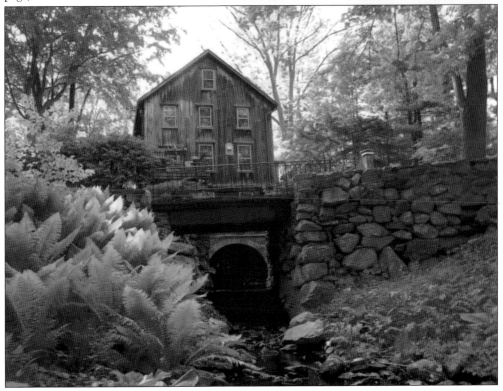

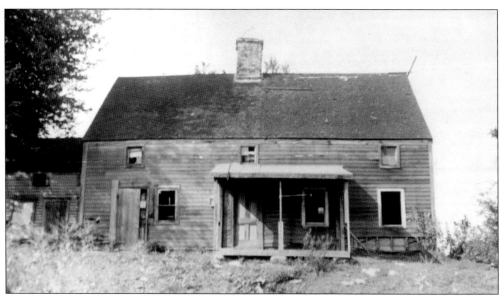

SALEM HOUSE. The above 1930s photograph shows a North Salem home in a dilapidated condition before being purchased by Hiram Halle and moved to the present site. Halle rebuilt this house using much of the original home, as was his custom. However, the new house was a composite of three structures: a small house from Bedford, a barn from Danbury, and this 1756 farmhouse. These separate structures where incorporated together and added to with much of this original homes timber. The new house, pictured below, contains eight fireplaces.

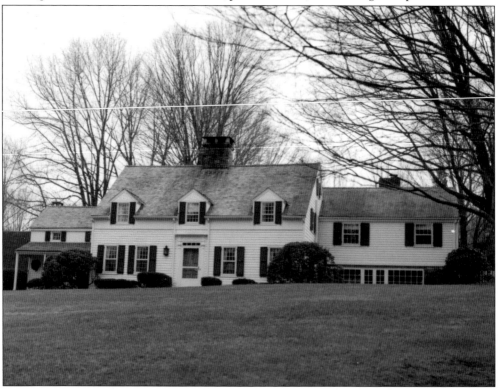

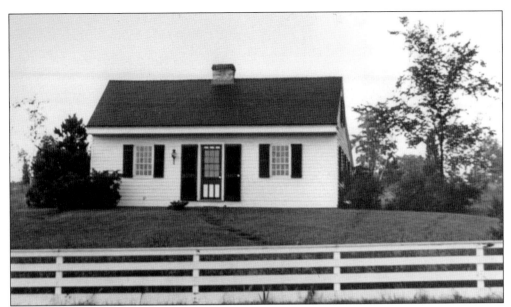

ALICE TOMLINSON COTTAGE. In the 1930s, Hiram Halle moved a Salem, Massachusetts, grocery store to Salem Road where it became an office for his architect, Walter Gillooly. In the 1940s, Alice Tomlinson, the last of the Lockwood descendants in Pound Ridge, took over the cottage. Alice was great-great-great-granddaughter of Capt. Joseph Lockwood. In 1970, it was bequeathed by Tomlinson to the library. Tomlinson was a "little person" and everything she owned was scaled to her size.

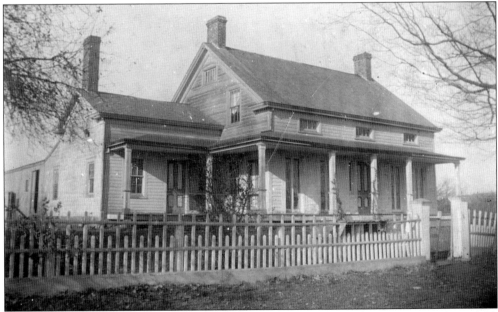

GEORGE SCOFIELD HOME. This 1910 photograph shows the home of George and Sarah Scofield, which they purchased in 1872. Georgia Belle Scofield was born in this home in 1874. The 1862 deed identifies the home sold by Anson Green as "with all buildings thereon and beginning at the highway leading from Poundridge Village to Boutonville." Note the floor-to-ceiling windows, which are similar to the Partridge Thatcher House located on Pound Ridge Road.

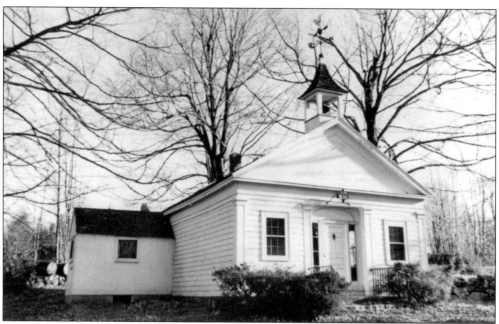

VILLAGE SCHOOL HOUSE, 1905. In 1851, land was donated for a new schoolhouse where the library is today. At that time, the District No. 5 schoolhouse was adjacent to the Presbyterian church and was about 30 years old. A new schoolhouse, pictured below, was built on the donated land, and the building remained a schoolhouse until 1939. During World War II, the building became the headquarters of the local Red Cross. After the war, the Hiram Halle Estate donated the schoolhouse and a parcel of land to the newly created library association. The Hiram Halle Memorial Library opened in 1952. Its core, the reading room nearest the main road, is still this old schoolhouse; but additions in 1955, 1964, and 1971 have considerably enlarged the building.

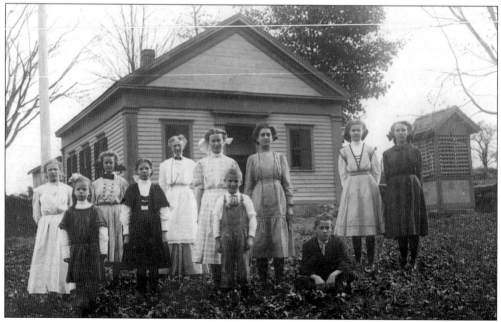

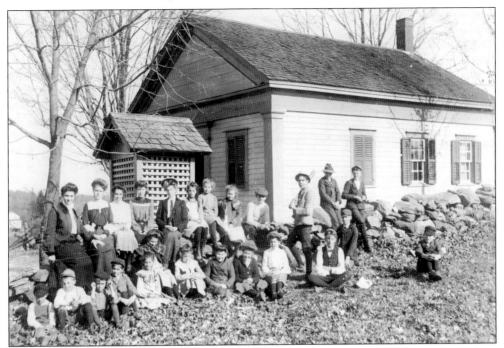

VILLAGE SCHOOL CLASS, C. 1920. This photograph helps depict the degree of ages in a one-room schoolhouse. The teacher would focus on one age group while the others performed quiet assignments. At this time, there was no such thing as tenure.

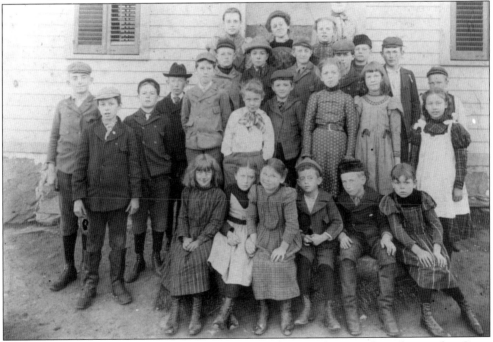

VILLAGE SCHOOL CLASS, C. 1930. This school photograph was taken during the Great Depression of the 1930s. The children's clothing clearly depicts the economic changes, compared to the previous photographs, brought upon by this troubled time.

CAPT. JOSEPH LOCKWOOD HOUSE AND BARN. Capt. Joseph Lockwood, brother of Maj. Ebenezer Lockwood, built this house around 1760 upon his marriage to Hannah Close. Prudence Lockwood Smith told her granddaughter how she wanted to rush out and see the British when they raided Poundridge. She was only 13, and her mother pulled her back and drew the shades. The captain's descendants retained ownership of the house until 1939, when it was sold out of the Lockwood family by Capt. Joseph Lockwood's great-great-granddaughter Helen Smith Tomlinson. She and her husband, Dr. Edward F. Tomlinson, built the side porch and made other major alterations to the house at the dawn of the 20th century. The house was originally a center-chimney house. Alice Tomlison is on the steps. The photograph below shows the barn, the pump house, the feed house, and the pigsty behind the trees. (Above, courtesy of Peter Uhry.)

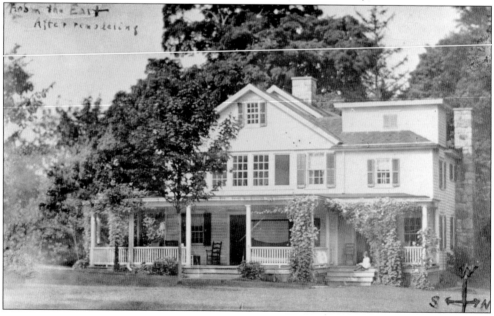

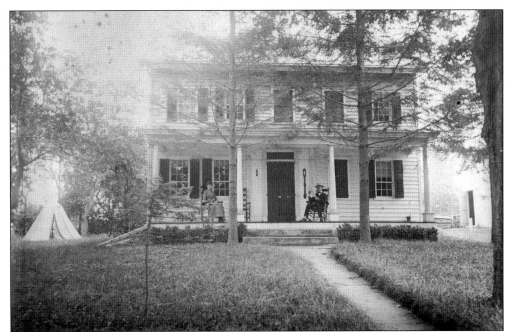

JOSEPH LOCKWOOD HOUSE. Joseph Lockwood, a son of Capt. Joseph Lockwood, probably built this house in the late 1780s when he married Mary Drake. At that time, it was a typical center-chimney, one-and-a-half-story house. Later in the 19th century, the roof was raised to enlarge the house. Subsequent owners include the Parsons, the Samuel Parkers, and the Schellings.

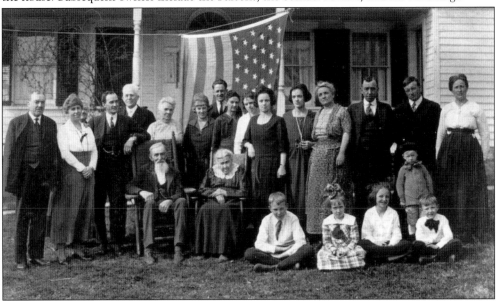

GEORGE AND SARAH DIXON CLAN. This is a family photograph of George E. and Sarah E. Dixon and four generations of their descendants. It was taken on April 4, 1924, to celebrate the 65th wedding anniversary of George E. Dixon and Sarah E. Birdsall. During the Civil War, George was a guard at the Old Arsenal Pentitentiary, Washington, D.C. He was also assigned to the courtroom during the Abraham Lincoln conspirators' trial where he witnessed the executions of George Atzerodt, David Herold, Lewis Powell, and Mary Surratt.

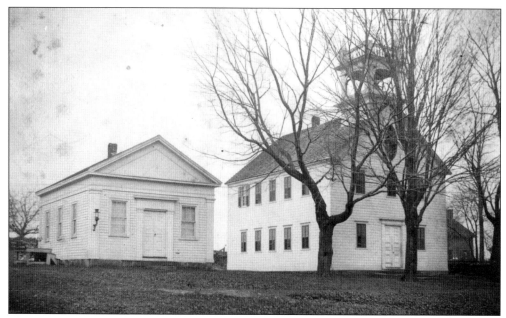

POUND RIDGE PRESBYTERIAN CHURCH. The first Pound Ridge Presbyterian Church was built in 1760. It was destroyed by the British during Banastre Tarleton's raid in 1779 and replaced by a second church (pictured above) in 1786. The second church had a square steeple. The lecture room was later moved from the north side to south side of the church.

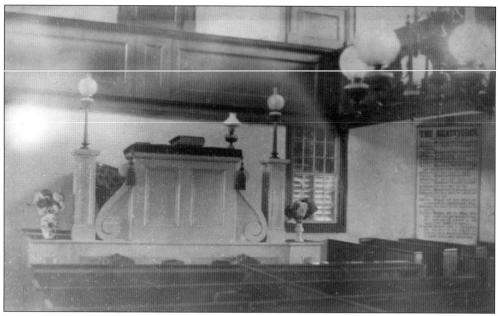

POUND RIDGE PRESBYTERIAN CHURCH INTERIOR. This photograph shows the interior of the second Presbyterian church around 1880. Rev. William Patterson served in the second church 54 years from 1835 until his death in 1889.

WILLIAM PATTERSON MEMORIAL CHURCH. The church razed the second building and in 1893 built the William Patterson Memorial Church (pictured here). This was the third and final church built by the Pound Ridge Presbyterian congregation. The church was sold in 1949 to the Pound Ridge Community Church, which renamed the building Conant Hall to honor Ernest L. Conant, who had been instrumental in the building's purchase. In 1983, the Pound Ridge Community Church donated Conant Hall to the town for a community center.

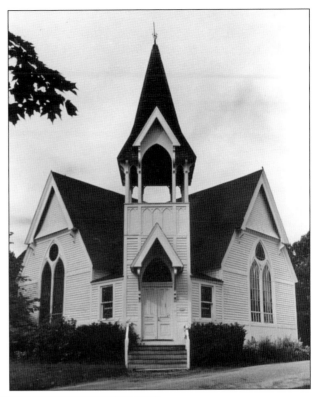

WILLIAM PATTERSON MEMORIAL CHURCH AND LECTURE ROOM. This 1895 photograph shows the third church and women's lecture room in their final position. These buildings function today as Conant Hall and the Pound Ridge Museum.

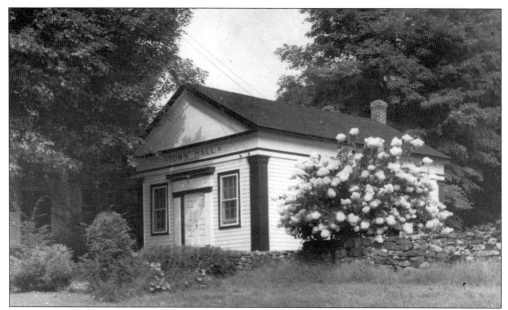

Presbyterian Church Lecture Room. This building (above) was erected in early 1853 as a lecture room associated with the Presbyterian church (now Conant Hall). The building was probably erected on the site of the former District No. 5 schoolhouse (1820–1851) after a new schoolhouse was built farther down the road on the site of the present Hiram Halle Memorial Library. Two members of the Female Sewing Society, which raised the money to construct the lecture room, donated the land for the new schoolhouse. In 1921, the Presbyterian Church sold the building to the town for a town hall. The *c.* 1983 photograph below shows the building in its current use as the Pound Ridge Historical Society museum. The historical society leases the building from the town.

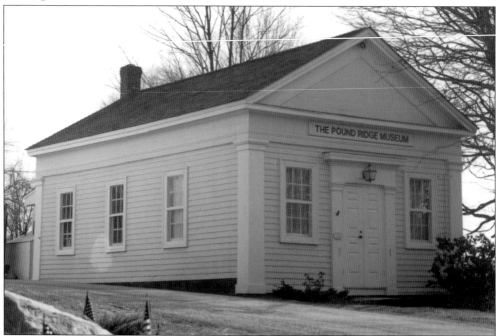

SAMUEL PARKER'S STORE, 1906. In 1906, Samuel Parker purchased Jesse Parsons's house (the former Joseph Lockwood property) and constructed a new store next to the house. In 1922, Andrew Schelling purchased both the house and the store and in 1928 sold both to his son Ernest. Thirty years later Ernest sold the house, but the Schelling family continued to run the store, Schelling's Market, for some years after that. The store bearing the name Samual Parker's continues until this day.

SUNDAY AFTERNOON, C. 1905. Rev. Thomas B Miller, pastor at Pound Ridge, is seen with George Scofield in front of the Scofield House.

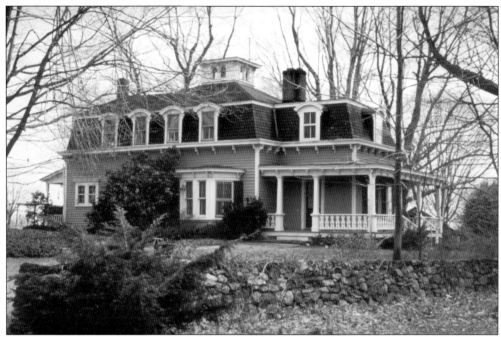

LEWIS LOCKWOOD HOUSE. Lewis Lockwood, the son of Judge Ezra Lockwood, probably built his home around 1833, at the time of his marriage. Sturgis Northrop purchased the property in 1868 and added the mansard roof, cupola, and other Victorian-era features. In 1959, his granddaughter, Mabel Williams, sold the house to the Pound Ridge Community Church, which, in turn, sold it to a private owner in 1965.

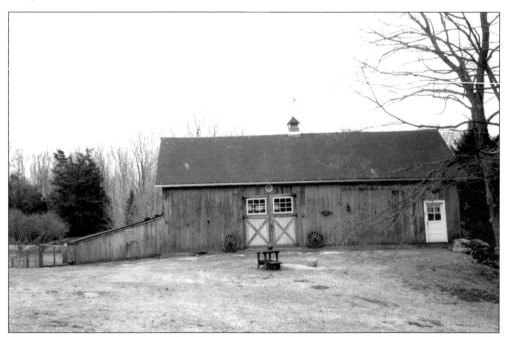

ALBERT LOCKWOOD BARN. This barn was part of the property built in the 1820s by Albert Lockwood.

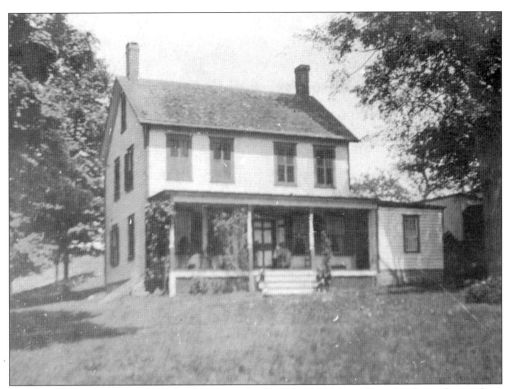

ALBERT LOCKWOOD HOUSE. This home was built in the 1820s by Albert Lockwood, grandson of Maj. Ebenezer Lockwood. It was later sold to the George Dixon family in 1881. Also pictured is a Colonial-era root cellar. (Above, courtesy of Ed Isaacs.)

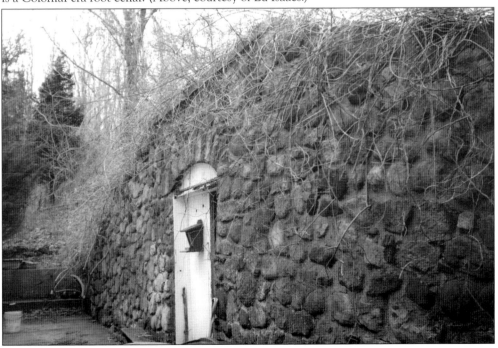

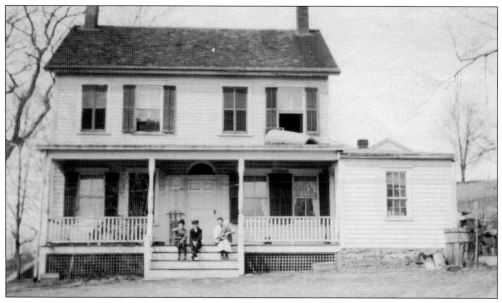

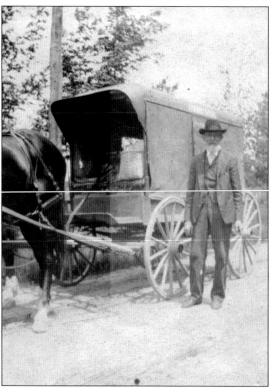

GEORGE DIXON HOUSE AND BUGGY. George E. Dixon was born in Poundridge on December 2, 1834. His parents were Alexander Dixon and Lemira Saunders. George married Sarah Birdsall in 1859. The Dixons and Birdsalls were residents of the road known today as Lower Shad while the Saunders were residents of the road known today as Upper Shad. In 1881, George and Sarah Dixon purchased a house and 18 acres beginning at "the highway leading from Poundridge Village to Stamford," known today as Westchester Avenue (north of the town park). He and his wife occupied this home until their deaths in 1925 and 1927, respectively. In his Civil War diary, George writes, "I was in the court room that day while the witnesses were being examined and saw the bullet that killed the President also the pistol and two carbines, Booths photograph and the boot that was cut open to take it from his broken leg by Dr. Mudd." (Left, courtesy of Ed Isaacs.)

POUND RIDGE NURSERY TOWARD HAMLET. This photograph was taken from the Pound Ridge Nursery looking northeast just to the right of the current flagpole and shows the eastern side of Westchester Avenue. The large white home on the picture's left is Lewis Lockwood's, the steeple of Conant Hall is in background, the small white house was the caretaker's cottage for Northrop farm, and the wood two-story barn is gone. The stone barn, which supplied water to the farm and Conant Hall, still has the water tank inside.

POUND RIDGE NURSERY TOWARD HIGH RIDGE ROAD. This view shows the area of Westchester Avenue just south of Pound Ridge Road looking east from the nursery property.

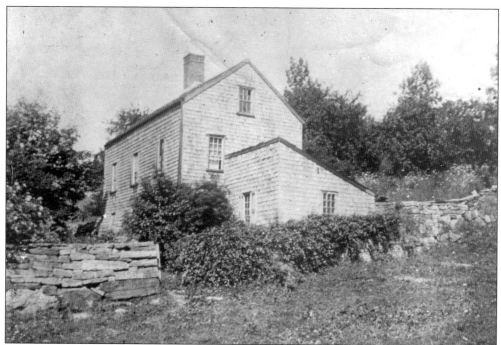

MURPHY HOUSE. West Lane has had other names in the past. A family by the name of Murphy lived in the house at the southwest corner of Westchester Avenue and West Lane. The road was then called Murphy's Lane. One of the Murphys' sons received a Congressional Medal of Honor for heroism in the Civil War. Before that, a family named Hoyt lived in the house and the intersection was known as Hoyt's Corner.

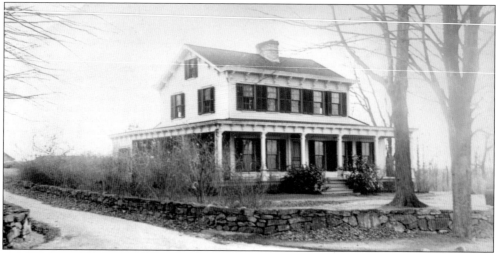

MILLER, MEAD HOUSE. This house is located on the south side of Pound Ridge Road and was owned by David W. Miller from 1848 to 1874, followed by Andrew Mead until 1901. The entire porch was removed during renovations by Hiram Halle.

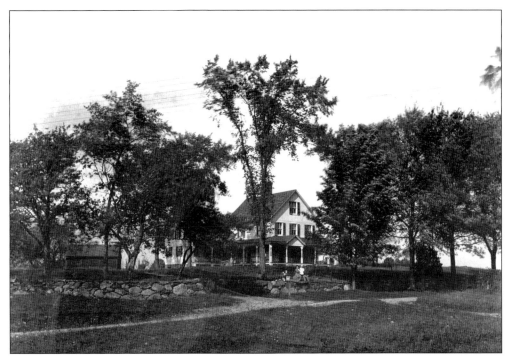

FRED R. SCOFIELD HOME, SUNSET VIEW FARM. Fred R. Scofield owned a home on a large farm that he called Sunset View Farm. It was at the present-day intersection of Hoyt Road and Pound Ridge Road. The dirt road in front of the home is Pound Ridge Road. These 1907 photographs were taken on the second birthday of Carleton Scofield. The photograph above shows the house and land. In the photograph below are Fred, Prince the dog, Fred's wife Beth, and their son Carlton in her lap.

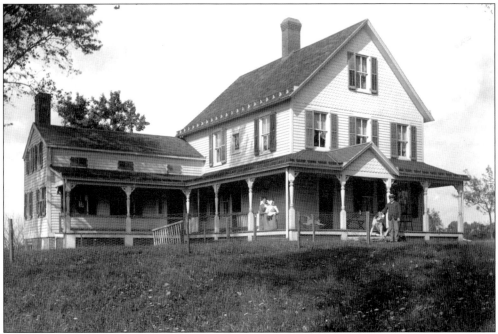

REVOLUTIONARY WAR SENTRY LOOKOUT. This photograph is of a sentry box used by American soldiers in the Revolution. It was located at what is today the intersection of Stone Hill Road, previously referred to as "the road from Bedford to South Salem" and Autumn Ridge Road. The photograph was part of a postcard sold in local stores.

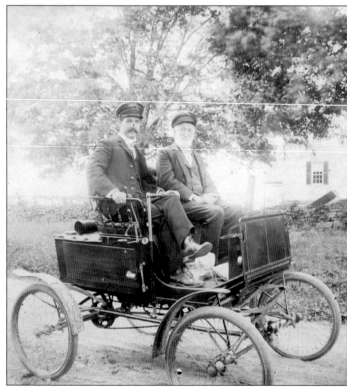

SCOFIELD CAR. This is a fine example of an early automobile owned by the Scofield family.

Three

BOUTONVILLE

Boutonville is named for the Bouton family, whose patriarch was Deacon John Bouton. He held the first deed in this area in 1753, which is extremely early for the Boutonville area. He had five children, John, Daniel, Steven, Gould, and Nathaniel, who settled in the area in 1770. This area was also known as School District No. 6 on the 1867 DeBeers map. The school districts were organized in 1812.

During the 1700s, Boutonville found itself at the center of a 50-year land dispute concerning overlapping grants to the Stephanus Van Cortlandt manor grant and to the Stamford patentees. After a lengthy legal battle, clear title to the 3,000 acres was finally given to Van Cortlandt heirs in 1788. Most of this land is now part of the Ward Pound Ridge Reservation.

Boutonville was a thriving hamlet even before Poundridge Village reached its peak. It contained a post office, store, school, sawmill, and gristmill. Oxen played a huge part in dragging the boulders on stone boats to build the stone walls. They were also used to rescue horses and wagons from the deeply mired mud roads.

The post office and store of Seth Abbott first opened in this area on March 9, 1852. Mail came weekly by stagecoach from Stamford or Ridgefield. There was also a tavern in the settlement. A tavern owner could not permit cockfighting, disorderly conduct, gaming tables, or shuffleboard. The temperance society of School District No. 6 was organized in 1835.

The Kitchiwan section of Boutonville is where mastodon bones were found by a resident in the early 1980s. An archaeological dig followed, and partial remains of a 10,000-year-old mastodon were excavated.

Names to keep in mind as inhabitants of Boutonville are Stevens, Harrison, Moore, Abbott, Bouton, Adams, Avery, Hull, Smith, Delavan, Scofield, Lawrence, and Bishop. Several of the homes are listed on the Revolutionary War maps by Robert Erskine, Gen. George Washington's cartographer.

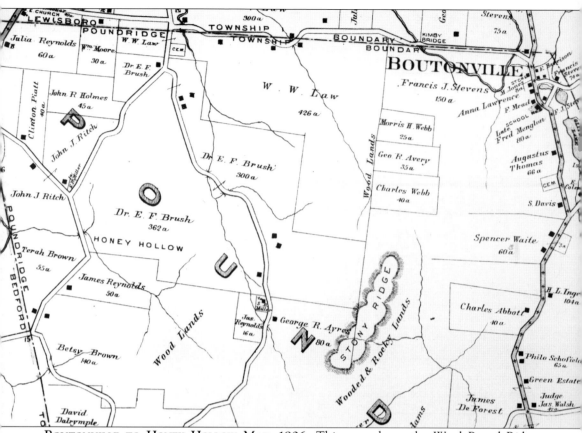

BOUTONVILLE TO HONEY HOLLOW MAP, 1906. This map shows the Ward Pound Ridge Reservation prior to being converted into the largest county park. The name of Ward was added in dedication to the man whose energy brought this park to life.

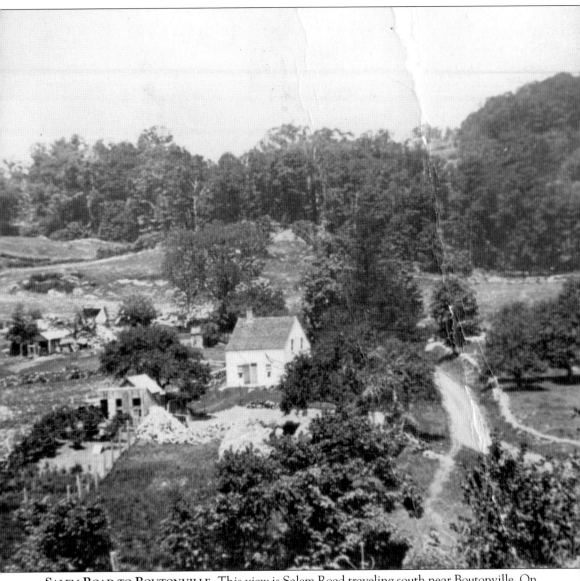

SALEM ROAD TO BOUTONVILLE. This view is Salem Road traveling south near Boutonville. On the right, west, is the general store and post office, while on the left is Adam Moore's home and hat factory.

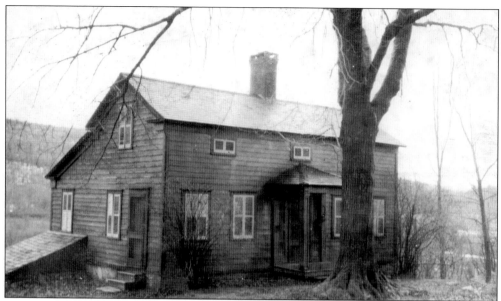

HOLMES, BOUTON HOME. This home was built around 1784 by John Holmes, who also operated the sawmill across the street. Later Joel Bouton bought the home in the mid-1800s, followed by Elbert Mead and John Williams.

HOLMES SAWMILL. The origin of the Holmes sawmill at Boutonville is unclear. It may have been built as early as 1760 by an unknown entrepreneur from Stamford or by Gen. Philip Van Cortlandt in the 1780s. The authors do know it was operated by John Holmes and his son John Jr. from 1786 to 1824. The mill continued to operate until shortly after 1900 under several different owners. The structure no longer stands.

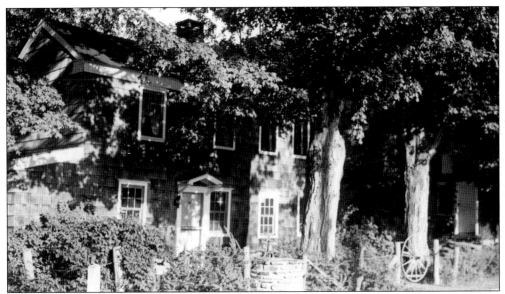

ADAM MOORE HAT FACTORY. Samuel Bouton, a tanner, built this home in 1820. He would soak oak tree bark to get the tannin and then tan leather with it. In 1836, Adam Moore bought the home. He used it as a hat factory, a winter cottage industry when not farming, where he prepared hat parts for a Danbury hat factory. Charlotte Droogan bought the home in 1925 and used it as a weekend home until her death in the 1980s.

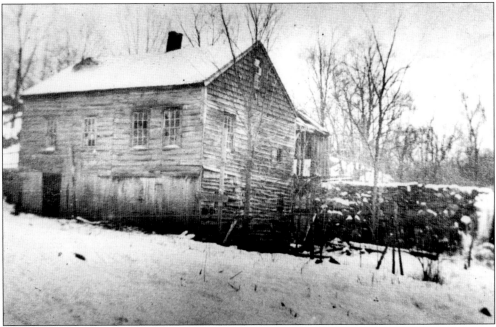

BOUTONVILLE GENERAL STORE AND POST OFFICE. This rear-view 1900 photograph is of the post office (built in 1851) and store (built in 1844) run by Seth Abbott. Mail came weekly by stagecoach from Stamford and Ridgefield, Connecticut. Across the street was the original Boutonville schoolhouse, built in 1830 and later moved to South Salem as a woodshed. By 1911, the Waterbury family owned the site and was operating a sawmill in addition to the post office.

BOUTONVILLE ROAD. This photograph from late in the second decade of the 20th century was taken in front of the Charlotte Droogan home and shows Boutonville Road heading toward the post office. Boutonville Road was paved in 1922. (Courtesy of Phil Pessoni.)

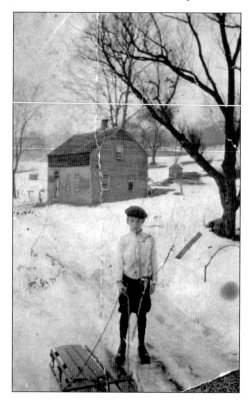

ELMER JONES SLEDDING. This early-1900s photograph is of Elmer Jones sledding near Seth Abbott's house. This home was destroyed in the 1930s when a truck lost control coming down the hill, entered one side of the home, and exited the other.

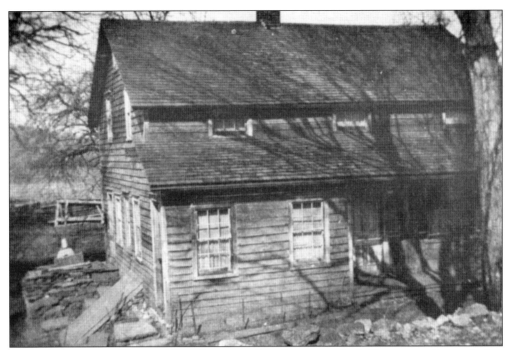

MINOR LAWRENCE HOUSE. This fine example of a one-and-a-half story, eyebrow-window farmhouse on Salem Road was built by Minor Lawrence (1771–1851) about 1820. Minor Lawrence was the son of Samuel Lawrence of Cross River, who was a militia captain during the Revolution. Minor's son John inherited the house and lived there until he died of pneumonia while serving in the Civil War. His widow lived in the house until her death in 1911 at age 90. The Lawrence family retained ownership of the property until 1926. Elinor Barnard (1927–1943) owned the home in the mid-1900s. She painted portraits for King Edward VII and King George V. The photograph above is an earlier image than the photograph below.

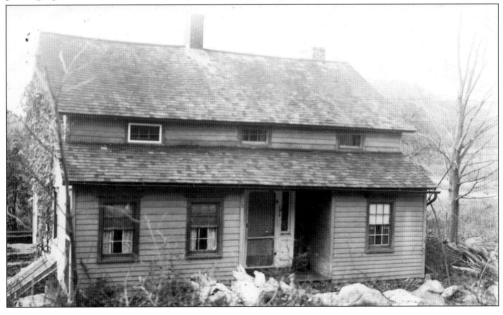

NORMAN LAWRENCE, JAMES LAVERY SR. HOUSE. This 1920 photograph shows the Norman Lawrence home built around 1822. It was purchased by James Lavery Sr. around 1877. It was located next to the general store. The Lavery home, general store, and several outbuildings were torn down by the county when it purchased the land to create the Ward Pound Ridge Reservation.

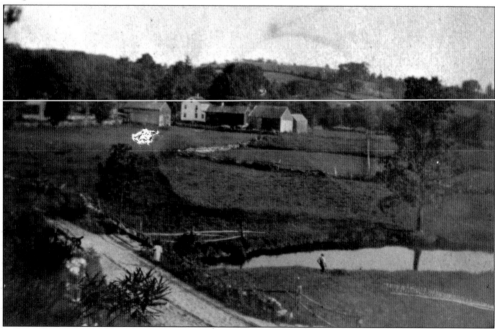

BOUTONVILLE VILLAGE, C. 1905. Salem Road is in the foreground. The buildings are on Boutonville Road, which extends into the Ward Pound Ridge Reservation. They are, from left to right, an unknown barn, Seth Abbott's house, the general store, and Norman Lawrence's white home with several outbuildings from the property. (Courtesy of Phil Pessoni.)

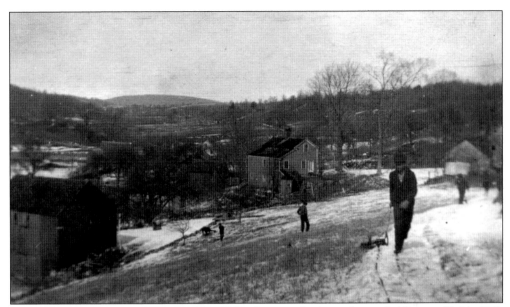

BOUTONVILLE VILLAGE, C. 1928. The 1903 photograph above shows sledding on Pickle Hill. The hill was planted with cucumbers grown for the pickle factories in Stamford, Connecticut. The Holmes-Bouton house is center. Below is the view from Boutonville Road in the reservation toward Salem Road. From left to right are Adam Moore's home; up the hill is Elmer Jones's white home, which is on the east side of Salem Road; behind and farther up the hill is the roof of the Stevens home; to the right is the Seth Abbott home; to the far right is the Minor Lawrence home; and behind is the white Holmes-Bouton house. The empty area between the Abbott and Lawrence homes is land that, by 1928, Westchester County had purchased to make the Ward Pound Ridge Reservation. In so doing, they tore down the general store and the Norman Lawrence home. (Courtesy of Phil Pessoni.)

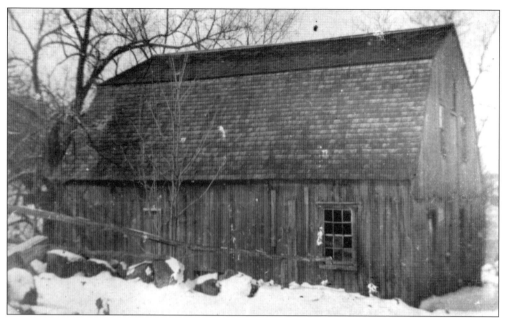

STEVENS GRISTMILL. Boutonville was once the center of water-powered industry in northern Westchester. Gen. Philip Van Cortlandt most likely built a gristmill on this site in the 1770s that Sylvanus Stevens operated. The gristmill, no longer standing, was abandoned around 1900. At its peak in the early 1800s, Boutonville was also the home of John Holmes's sawmill, Aaron Hull's fulling mill and carding machine, and Samuel Bouton's tanbark mill.

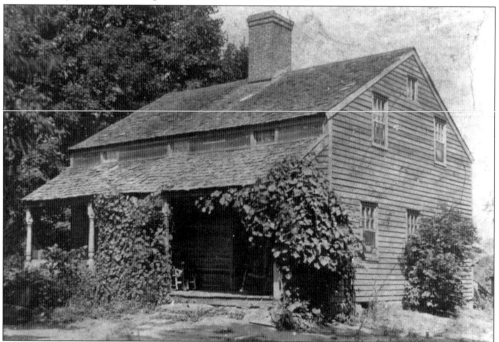

DELAVAN, COLEMAN, O'NEIL HOUSE. Thomas Coleman, of Somers, bought this house in 1884. His daughter Mary married Lawrence O'Neil, and she lived in this house until her death in the 1990s. The person sitting in the rocking chair on the porch is believed to be Annie Coleman.

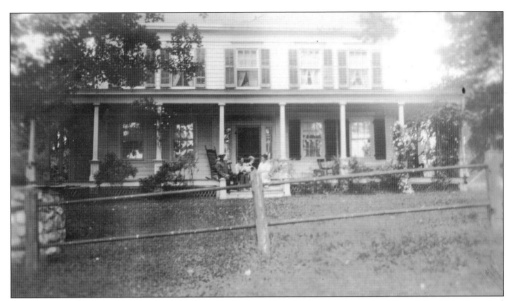

SYLVANUS STEVENS HOUSE. Sylvanus Stevens was a sergeant in the 5th Continental Regiment during the Revolution. His Boutonville Road house, an outstanding example of full two-story, center-chimney Federal design, was most likely built around 1810. It remained the Stevens homestead for 140 years, occupied by Sylvanus's grandson John Delavan Stevens and great-grandson Frank J. Stevens. Near the end of the 19th century, a full front porch was added, but has since been removed.

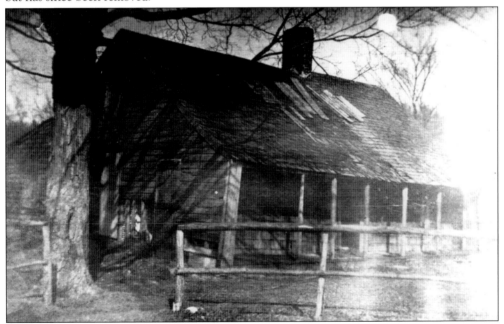

BOUTON-AMBLER-LAVERY JR. HOUSE. This photograph shows a home originally built by Enoch Bouton around 1778. Enoch's father, Daniel, arrived in Boutonville in 1765. It is very possible that this home was built on the foundation of the original family homestead. Lewis Ambler purchased the home around 1840. Around 1880, it was sold to James Lavery Jr., son of James Lavery Sr. This home no longer exists.

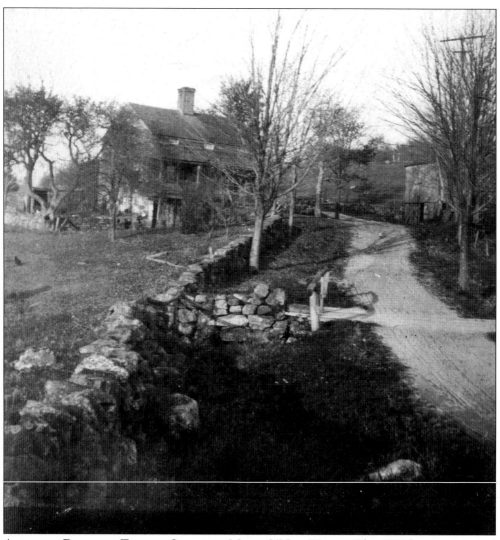

ABRAHAM DELAVAN, THOMAS COLEMAN, MARY O'NEIL HOUSE. This 1776 home is pictured in a late-1800s photograph on Salem Road. Abraham Delevan was born in 1767, but the house may have been built in the 1760s. The basement level was a summer kitchen with a bake oven. The house had two front doors because Abraham's son Hiram lived in the left side in the 1840s, when an addition was built onto the left side toward the rear of the house. The foundation still exists today. The 1830s deed refers to initials carved in a boulder, which are still visible.

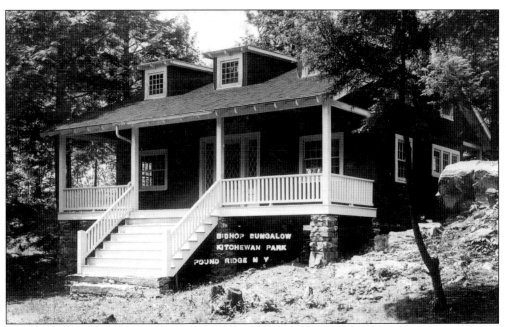

BISHOP HOUSE. This home is on Kitchawan Lake and was part of an older section called Kitchawan Park, now known as Bishop Park.

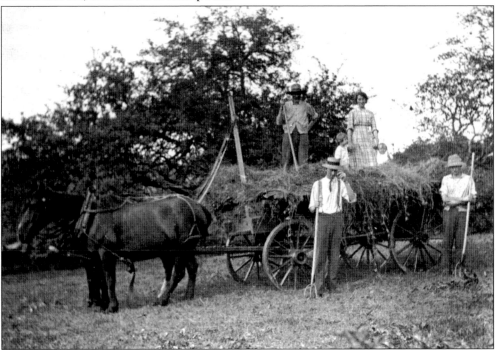

HAYING ON SCOFIELD FARM. Both sides of Salem Road were maintained as a large dairy farm with an ice pond until 1920. Native Americans occupied this area because of the abundance of game and springwater. Several Native American artifacts, projectile points, and arrowheads have been discovered on the Scofield farm. The New York Archaeological Society places their age at 5,000 to 7,000 years BC. The land is now owned by Aquarion Water Company.

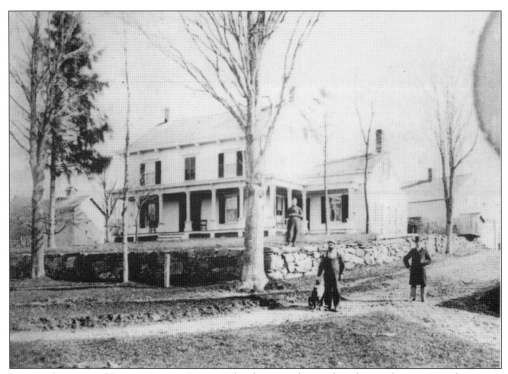

JOSEPH SCOFIELD HOUSE, SALEM ROAD. This house is located in front of a pre–Revolutionary War home site. The Scofields were original settlers. The family's holdings went north from Poundridge Village along Route 124 until it abutted the South Salem/Lewisboro border. The pre-Revolutionary home, built between 1743 and 1745, no longer exists. The present house has been standing since 1840. It was the first house in Pound Ridge to have electricity installed. Below is a photograph of Joseph's horseless carriage.

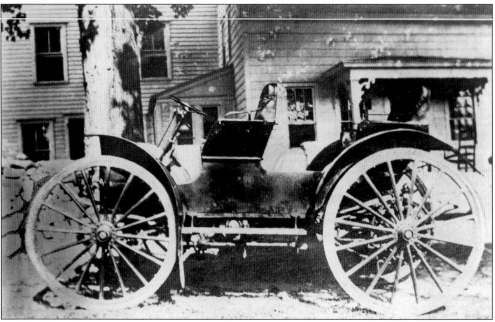

EZRA SCOFIELD BUZZ SAW. Ezra Scofield owned the first buzz saw in Poundridge.

AZUBA RAYMOND HOUSE. Early-1800s deeds record this house as belonging to Henry Scofield and his wife Azuba Raymond Scofield.

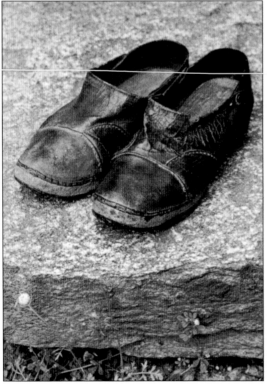

SCOFIELD SHOE FACTORY. Charlie Scofield operated a shoe factory on Salem Road and made Lancaster clogs. Shoemaking was the largest nonfarming industry in town, employing 141 cordwainers. Charlie patterned his clogs after those made by his ancestors in Lancaster, England. His clogs had innovative wood soles for wear in the muddy barn.

MARSHALL/ABBOTT HOUSE. LeGrand Abbott married the daughter of Hannah Marshall Tyrell around 1822. He built a home on 60 acres inherited from Hannah's grandfather, Anthony Marshall. This late Federal-style, two-story house on Salem Road likely was rebuilt around the center chimney of the original 1780s Marshall homestead as suggested by the beehive oven in the side of a main-floor fireplace. Glittering Pond, which used to power the two Boutonville mills, was across the road.

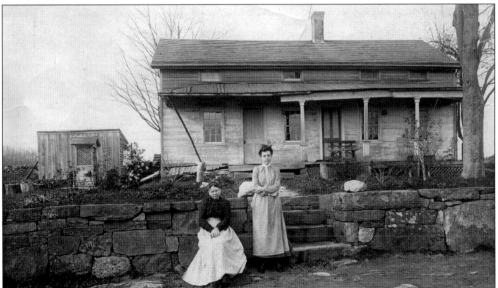

GARDNER MARSHALL HOUSE, 1910. Pictured in front of this Salem Road home is Sarah Frances Scofield Marshall (1856–1945), wife of Gardner Marshall (1848–1940), and a daughter Frostie Marshall. Their lineage descends from Amon Marshall who enlisted in the Revolutionary Army in 1775 and volunteered for six tours of duty over three years. He fought at Fort Ticonderoga and throughout Connecticut and Westchester. In his Revolutionary War pension petition, Amon describes many skirmishes with the British and one where he was commanded by Gen. Benedict Arnold. William, Albert, and Nathan Lockwood, and John Fancher attested, "Amon was a good & faithful Soldier and a true friend to the Independence."

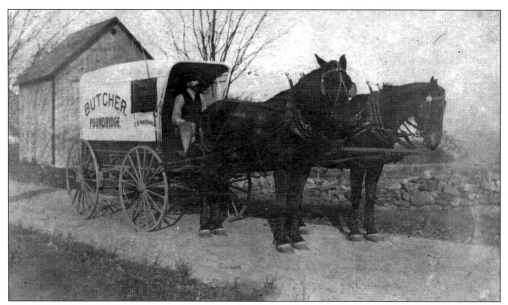

MARSHALL BUTCHER WAGON. The Marshall meat market was known as the Hillsdale Market, and the meat delivery wagon was on exhibit at the Danbury Fair Grounds after it was retired.

SETH MARSHALL HOUSE. The earliest written record of this house is an 1823 mortgage deed from owner Seth Marshall in which mention is made of the "place where Marshall now lives." In 1832, Marshall sold the house to Andrew Mead, who owned the property well into the 19th century. The present house is a center-chimney, full two-story house with an attic.

SETH BISHOP. In 1840, Seth Bishop purchased the land from Ebenezer Abbott. A year later he built this home. (Courtesy of April Herbert.)

SAMUEL PIATT HOUSE. In 1815, Samuel Piatt (1773–1850) purchased seven acres and possibly an existing house from Gen. Philip Van Cortlandt. This home site is now on Honey Hollow Road.

TIMOTHY REYNOLDS HOUSE. Timothy Reynolds fought in the American Revolution. It is thought that he built this house after the Revolution. The center chimney and other construction methods indicate a late-18th-century date. The Reynolds family retained ownership of the Honey Hollow Road property until World War II. The family leased 50 acres to John Jay, president of the Second Continental Congress. In the 19th century, the house was extended to the right of the original house.

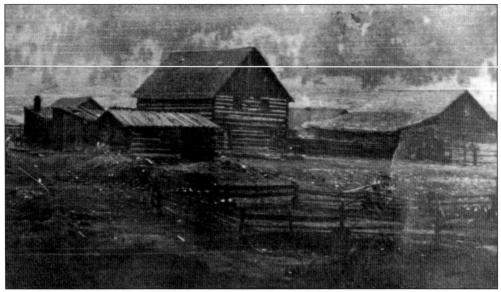

MASTENTOWN–CHARCOAL TOWN. A small charcoal industry thrived on the land that became the Ward Pound Ridge Reservation. It is thought to have been operated by a free African American named Masten. Colliers cut and stacked hardwood, forming a mound about 10 to 12 feet high. It took three weeks to reduce the hardwood to charcoal. Young boys were used to test the soft spots and were often seriously burned. (Courtesy of Phil Pessoni.)

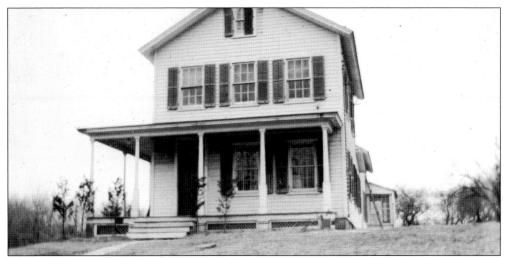

MITCHELL-LAWTHER HOUSE. This home is located on the south side of Stone Hill Road. The photograph above is a late-1800s photograph of the home. The photograph below is after Hiram Halle renovated it in the 1930s. The original home was extensively remodeled and expanded. Robert Lawther also sold the Town of Pound Ridge a large plot of land that is located west of the hamlet behind the school and Caroline's Grove.

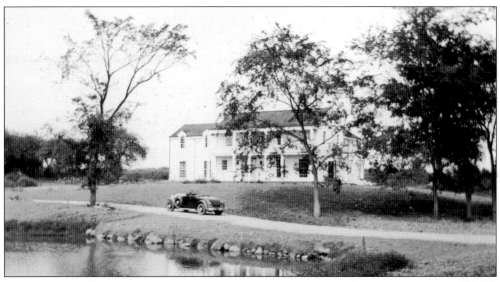

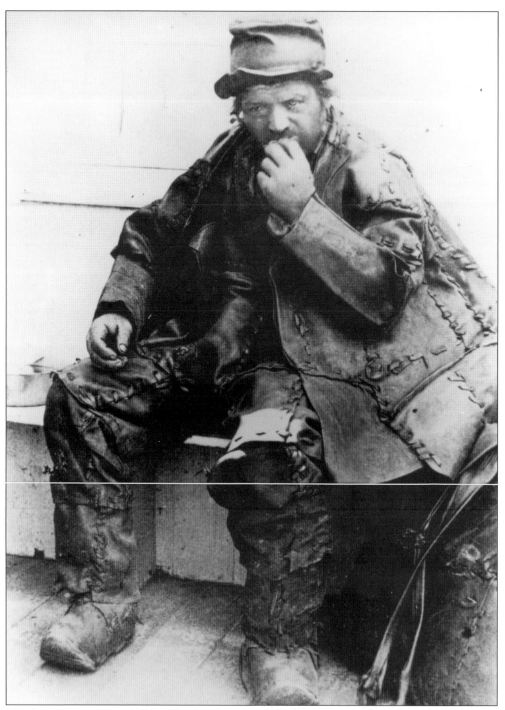

THE LEATHERMAN, C. 1880S. The Leatherman, Jules Bourglay, is a local legendary figure. A mysterious French hermit, the Leatherman roamed eastern Westchester County and western Connecticut for nearly 30 years beginning about 1860. Dressed in a patchwork leather suit, he followed a regular circuit of approximately 350 miles every 34 days, sleeping in caves or huts and taking meals at friendly farmhouses.

Four

BARNEGAT, EAST WOODS, FANCHER, AND TRINITY PASS

Most colonists in Poundridge were subsistence farmers who raised meager crops of corn, wheat, and flax, along with some cattle, hogs, sheep, and poultry. Dairy products were sold in nearby Connecticut towns.

Nearly every family supplemented its income in the 19th century by engaging in cottage industries, particularly in the winter months. The largest industry was shoe making, with 150 families participating. The precut shoe parts were brought from Long Ridge and New Canaan. Women and children did fine stitching of uppers and attached buttons and bows, while the men fitted the uppers and attached the soles. In the 1820s, leather shoes sold for $1.40 a pair. A shoemaker made $7 to $15 a week.

The people on Barnegat attended church on East Woods Road via a path through the woods. The mud during wet weather prohibited children from making this trip. Samuel Selleck decided to build the Selleck's Corners Chapel for the children in 1851. The chapel is on New Canaan land but served Poundridge.

Of the 17 houses recorded on Barnegat in 1901, 9 remain today. Four have bake ovens in the rear wall of their stone fireplaces, a technique builders abandoned by 1730. The Dutch called these stone kilns Barnegats. Perhaps that is the reason for the road's name.

Shirt making was a cottage industry on Barnegat Road. Shirt manufacturers on High Ridge and in New Canaan distributed parts that young girls and women sewed. A story is told about a father who made baskets on the ground floor, while his three daughters sewed shirts upstairs. He could tell when they got to chatting because the machines slowed down. At that point he would rap on the ceiling. His daughters soon perfected a system whereby one or two would sew while the third filled them in on the latest gossip.

A small cemetery on Barnegat contains the remains of the father of one of the only three soldiers of the American Revolution to receive the newly designed Purple Heart medal for wounds in battle. The medal was designed by George Washington.

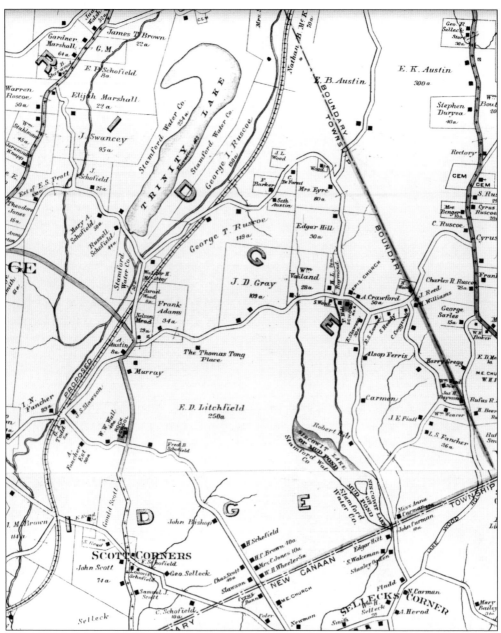

EASTERN AND SOUTHERN POUNDRIDGE MAP, 1906. This section of town has a rich history and is one of the most naturally scenic areas in Pound Ridge. This map serves chapters 4, 5, and 6.

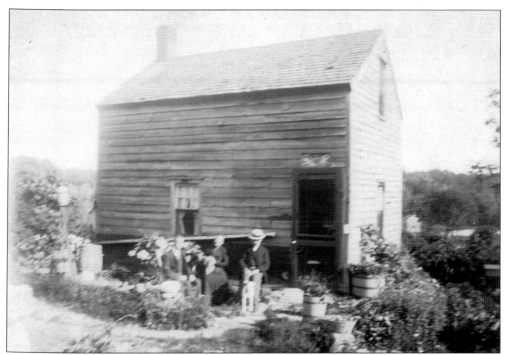

BETSY WHALEY HOUSE. The photograph shows the Betsy Whaley home on the eastern side of Barnegat Road, which no longer exists.

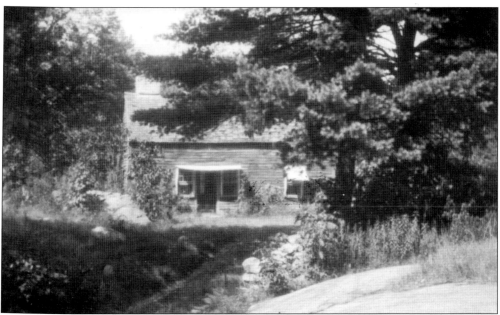

SAMUEL WHALEY HOUSE. The rear bake oven in the kitchen fireplace and the steep stairs indicate an early-1700s date for this Barnegat Road building. Samuel Whaley was living there by the late 1700s. The spring across the road was the only water supply as this home could not have a well dug due to the rock ledge. In 1859, it was auctioned off following the death of Samuel's grandson William Holly.

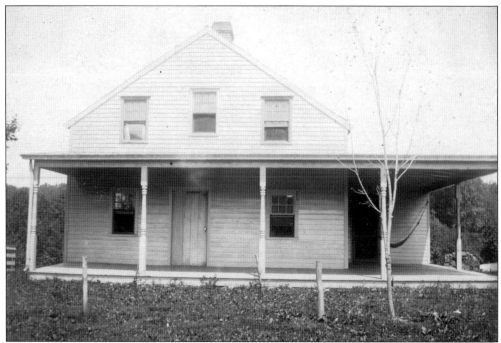

COLE HOMESTEAD. The Cole homestead was a wonderfully preserved old house until it burned down in the mid-1980s. Many Native American artifacts have been found around its natural spring. This home did not have a well, as it took water from a nearby spring.

CATHERINE JARVIS HOUSE. Catherine Jarvis was born in Norwalk in 1727. She inherited 110 acres on southern Barnegat Road from her father, John Raymond, who had purchased land in the east patent. Catherine had 11 children. A 1797 map shows her living in Poundridge. After her death in 1811, first her daughter and then her grandson owned the property until the 1850s. The home has been extensively altered since the mid-19th century.

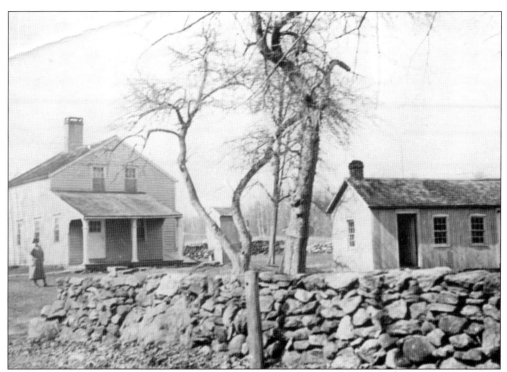

STEVEN JARVIS HOUSE. Stephen Jarvis, born in 1758, was a son of Catherine Jarvis, and built a one-room house on his mother's land around 1800. In the photograph above, this home is shown on the left after it was expanded. In the photograph below, subsequent owners constructed a wing to connect the house to the former basket shop of Lincoln Jones.

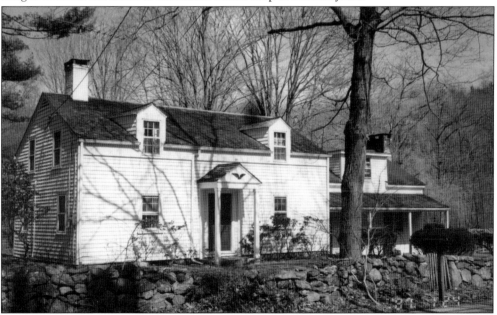

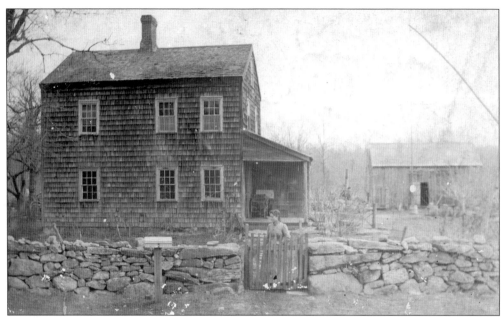

CARMAN HOME. This East Woods Road home was built by John Carman around 1920. He personally built the windows and doors previous to construction of the home. This could be the first prefab house in Poundridge. The woman standing is believed to be his wife, Bessie Carman. The 1920 census of Poundridge lists the road as the "road running from East Wood Church to Lake Siscowit." (Courtesy of Judy Carman Tomlins.)

EBENEZER SEYMOUR HOUSE. Ebenezer Seymour was born in 1729 and probably lived in this Barnegat Road house by 1750, when he reached his 21st birthday. However, two architectural features indicate that Seymour moved into an existing, early-1700s house. One feature is the rear bake oven in the kitchen fireplace. The other is the basement stonework, which suggests the original construction pattern of the house: first a front room (plus kitchen) with the chimney on one wall, then a second front room added later on the other side of the chimney, resulting in a center-chimney structure. The house retains its original story-and-a-half configuration.

RUFUS HOYT. Matthew Hoyt owned this home in 1820. By 1844, his son is recorded as owning the property.

BENJAMIN BROWN. The Brown family owned some 200 acres of land on both the north and south side of East Woods Road in the early 1800s. Benjamin Wilson Brown (1812–1882), a son, probably built this house on this land. An 1849 deed whereby he sold the property specifically mentioned a dwelling house.

NOAH WOOD BROWN HOME. Noah Wood Brown (1814–1889) inherited 60 acres of land from his father in 1835. This land was bounded on the south by what is the present-day East Woods Road. His grandfather William Brown settled in the eastern portion of Poundridge in the late 1700s.

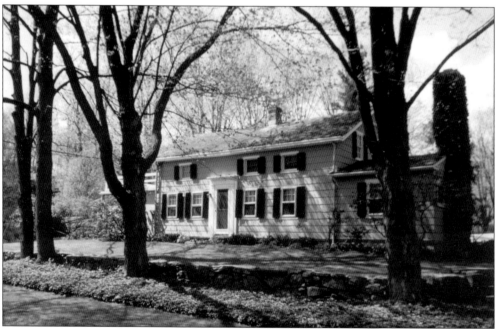

LINUS HOYT HOUSE. The first recorded mention of Linus Hoyt is in the 1830 census; thus, it is known that this East Woods Road house was built before that date. The building was originally a center-chimney, one-and-a-half story home. Although subsequent owners made extensive alterations to the house, its exterior still retains its early-19th-century appearance.

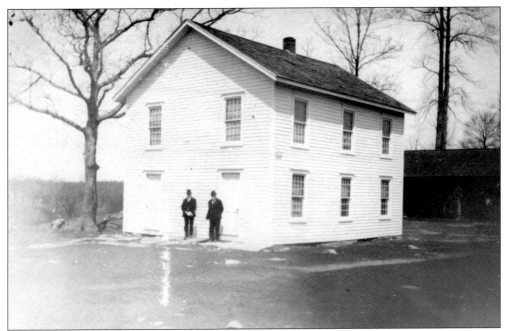

East Woods Methodist Protestant Society Church. The church was built in 1834 and stood at the northeast corner of the present-day intersection of East Woods Road and Old Church Lane. The church celebrated its 100th anniversary in 1934 but closed its doors a year later. The building was moved to Nancy's Lane and now serves as a private residence. The picture above shows Reverend Sutherland with an elder of the church. The picture below shows the steeple addition.

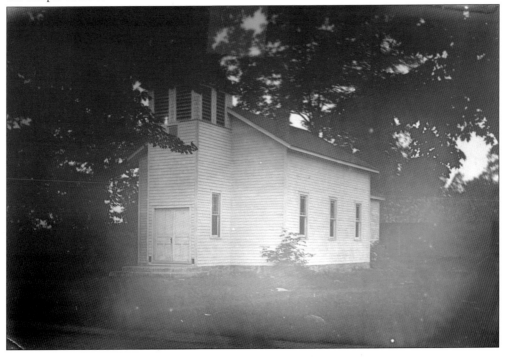

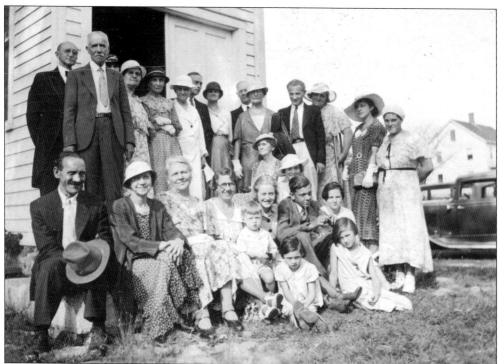

EAST WOODS METHODIST PROTESTANT SOCIETY CONGREGATION. About 1830, doctrinal differences split the Methodist Episcopal Church of America. The congregation in the eastern section of Poundridge became the newer Methodist Protestant Society while Poundridge Village and the Great Hill congregations where incorporated as the Methodist Episcopal Society. In 1939, Methodist Episcopal churches throughout the United States joined with Methodist Protestant churches to become the Methodist Church.

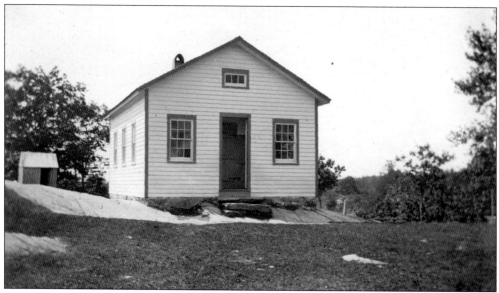

EAST WOODS SCHOOL HOUSE. This early-1900s photograph shows the one-room schoolhouse known as East Woods School. It is now a private residence.

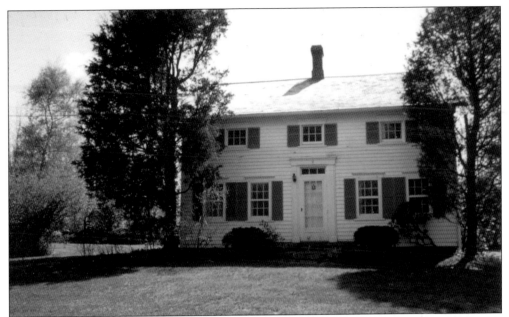

ELEAZAR SLAWSON. The earliest record of Eleazar Slawson is the 1842 assessment for his house and lot. However, the original story-and-a-half, center-chimney construction indicates a late-18th- or early-19th-century date for this East Woods Road house. There were originally two fireplaces off the center chimney. Eleazar Slawson was a carpenter and, according to the 1880 census, was still pursuing that trade at the age of 67.

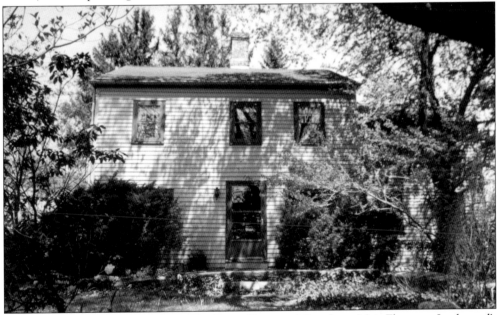

JAMES RAYMOND HOUSE. There is a James Raymond listed on Maj. Ebenezer Lockwood's roster of patriots. The 1799 road list also lists a James Raymond in the area of this Hack Green Road house. It is possible, therefore, that James Raymond built this house before 1800. The two-story-with-attic configuration would also indicate a late-18th-century date. There were originally three fireplaces off the center chimney.

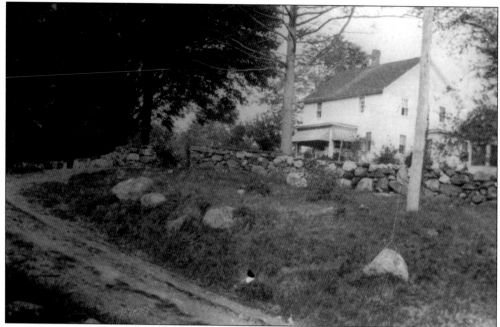

SLAUSON, FANCHER HOME. The Fancher home was one of the original homes on Fancher Road. The home was owned by Alonzo Slauson, "One Arm Slauson," who lost an arm loading the Poundridge artillery gun. He sold it to Bertram H. Fancher, who sold to John Vander Pyl. (Courtesy of Elyse Arnow Brill.)

FANCHER ROAD. Bertram H. Fancher bought the home from Alonzo Slauson and paid to have the road moved closer to his home. This photograph was taken before the road was moved and shows the prehistoric boulder as a reference point on the road. Today Fancher Road comes within three feet of this boulder. (Courtesy of Elyse Arnow Brill.)

FANCHER MEADOW AND BEYOND. This southwestern view shows the Fancher farm, which extended all the way to Scotts Corners as well as High Ridge Road. The meadow in the immediate foreground exists today as preserved open space owned by the Pound Ridge Land Conservancy. It is maintained as permanent open space by the Pound Ridge Land Conservancy via a gift from the present Fancher homeowners. (Courtesy of Elyse Arnow Brill.)

VANDER PYL HOME. This photograph, from the early 1900s, shows the Slauson, Fancher, Vander Pyl home in all its current glory. (Courtesy of Elyse Arnow Brill.)

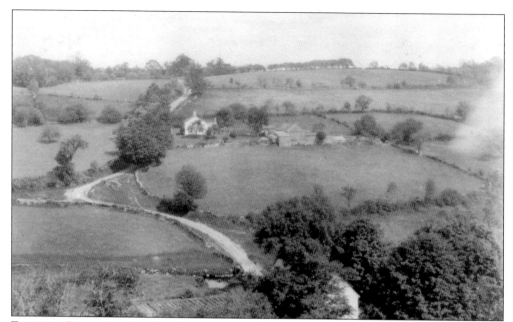

FANCHER ROAD. Fancher Road runs from south to north in this photograph. The left road is East Woods Road. The white house in the middle was built prior to 1760. In the early 20th century, the fields at the lower right of the photograph were temporarily converted into a baseball field. Lowell Thomas and his "Nine Old Men" played ball here in 1937 to raise funds to build a firehouse.

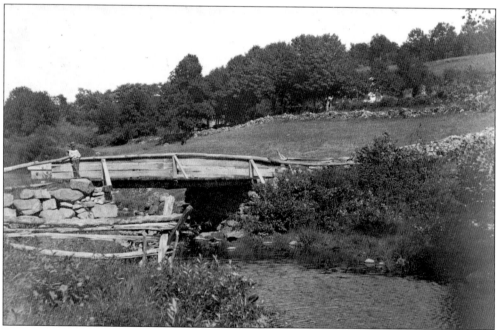

FANCHER ROAD WOOD BRIDGE. This wooden bridge on Fancher Road is in the southern section of the photograph above, over the stream just north of the large white home. The bridge was later replaced by the stone and steel bridge known today. This view is facing north toward Eastwoods Road, which runs along the stone wall at the top of the picture.

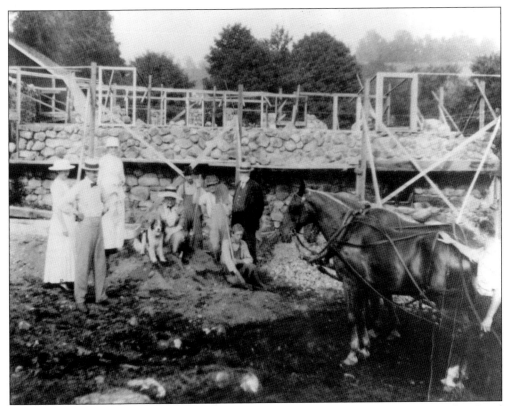

BARN BUILDING. This early-1900s photograph shows the construction of the Fancher Road barns by Bertram H. Fancher. These stone barns exist today and would be just south of the Fancher Road bridge. The barns were later converted into homes.

BOLTON, PHILBIN HOME. This property was originally farmed by George Dixon, who also owned a blacksmith shop. In 1928, Hiram Halle bought the property from Lucille Bolton and moved the house to its current location in 1934. The home is dated to the early 1800s. However, the stone stanchion holding up the well sweep indicates an earlier date.

THE BOYS OF SUMMER, 1937. In 1937, Lowell Thomas gathered many writers, authors, and radio celebrities to Fancher Road for a firehouse fund-raiser. His team, the Nine Old Men, won over George T. Bye's Prehistoric Sluggers 17-12, more or less. The game was broadcast live by NBC radio. His team consisted of Michael Connor, Homer Croy, Gregory Mason, Prosper Perenelli, Coloniel Stoopnagle, Frank Hawkes, Ted Shane, Dale Carnegie, and Frank Parker, among others. George Bye's team consisted of Heywood Brouni, Quentin Reynolds, Gene Tunney, Westbrook Pegler, Fredrick Tinsdale, H. W. Ross, Richard L. Simon, and Frank Buck, among others. Anna May Wong was the umpire. On why his team lost, George T. Bye said, "Then there was that player they introduced as Captain Frank Hawkes, all swathed in bandages. What an old trick. Why, that was none other than Babe Ruth draped like a mummy."

Five

TRINITY LAKE

Donbrook, Trinity Pass, and Barnegat Roads are shown on a 1797 map by Charles Webb as being the major route to Norwalk through New Canaan. It seems likely that this route was originally a Native American trail from the coast to planting grounds at "the head of Ponus" and thence to hunting and freshwater fishing territories in what is now the Pound Ridge Reservation.

Some feel that Donbrook should have been named Sniffen Road as Enoch Sniffen owned three houses and operated a large farm on Donbrook. Prior to that time, the farm had been owned and operated by John Waterbury. Enoch Sniffen held the post of overseer of the poor in 1844 and 1845. The overseer made sure no orphans or illegitimate children became town charges. Children as young as 11 were bound out as servants, and budding delinquents were apprenticed in trade. The overseer also saw to it that debtors could work off their debts by selling their labor.

Trinity Pass derives its name from Trinity Lake. In 1867, the Ridgefield and New York Railroad Company projected a line between East Port Chester and Ridgefield. Local farmers accepted railroad stock as payment for a 50-foot right-of-way. The 22-mile bed was graded and almost ready for track when it was abandoned for lack of funds in the panic of 1873.

Trinity Lake Reservoir and the surrounding water company lands have a rich history. Much of the land in this area belonged to the large Southeastern Farm Company, owned by Artemus Ward, the namesake and great-grandson of the Revolutionary War general. In 1912, Ward owned about 1,400 acres in Poundridge. Most of this land is now under water.

HIRAM HALLE. Hiram Halle was a most generous benefactor of Poundridge in the early 1900s. He bought the first of his Poundridge holdings in 1928, eventually owning 700 acres. His chief interest was in restoring old Poundridge homes. Thirty homes in Poundridge were rescued through his efforts. This gave 60 local men full-time employment in the midst of the Depression and allowed many local families to weather those difficult years.

HIRAM HALLE HOUSE. Hiram Halle was a successful businessman, an inventor, and an avid collector of art, architectural components, and antique furnishings. He developed the first process for waterproofing fabric, held the first U.S. rights to the diesel engine, and owned a number of patents for typewriters and business machines.

HIRAM HALLE ESTATE. In an example of his prowess, in 1941, Hiram Halle was ordered by the U.S. State Department to supply the Japanese with the information they needed to complete their ability to make high-octane fuel. He refused and challenged the government to jail him and take away his fortune. Fortunately, the government backed down, for just a few months later the Japanese bombed Pearl Harbor.

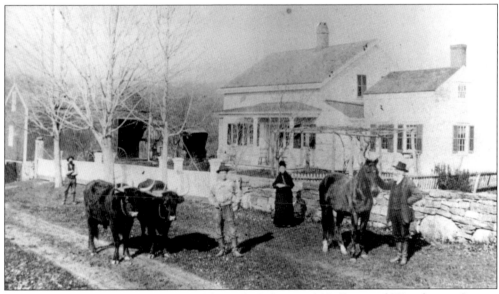

SCOFIELD, OLESEN, HALLE HOUSE. The 1851 Sidney and Neff map of Westchester County identifies this house as the home of Aaron Scofield (1826–1901). It was restored by Hiram Halle and used by his chauffeur and later his estate superintendent, Hermann Scheid. Halle disliked porches and Victorian design and had them removed from homes he restored. This home is located on the north side of Trinity Pass just west of Halle's house

LOUIS HALLE HOUSE. Louis Halle was the brother of Hiram Halle, and his house was situated on his brother's Trinity Pass estate. Although Hiram Halle usually renovated preexisting structures, on this occasion he chose to construct an original house. Built in the 1920s, the exterior was handcrafted out of stucco and half-timbers of chestnut and cherry. Many windows are leaded. The interior features beamed ceilings, wide floorboards, and five fireplaces. The property includes a remodeled carriage house and an authentic Swiss chalet.

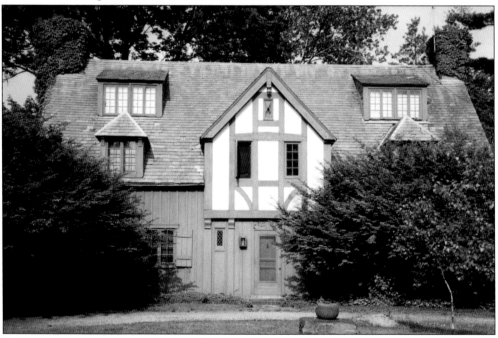

TRINITY LAKE RESERVOIR. In 1869, the Stamford Water Company purchased three ponds, Round, Middle, and Lower, and the land around them. They constructed an earthen dam (rear of picture), which merged the three ponds together as Trinity Lake. In 1895, the dam was increased in height, bringing the capacity from 300 to 450 million gallons. In 1965, a new dam was built. Several houses and parts of Trinity Pass and Old Mill River Road were submerged.

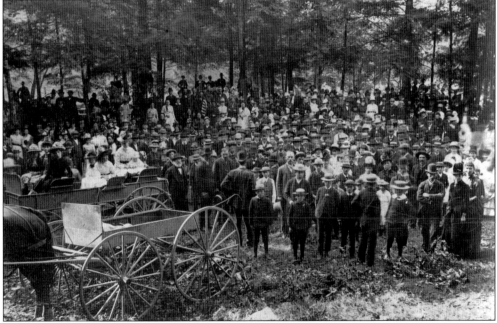

FARMERS' PICNIC, C. 1888. When the reservoir was enlarged in 1895, the road to a picnic area called Hemlock Grove was submerged and the water company built a new road. Up to that time, farmers' picnics had been held on the eastern shore of the lake with up to 2,000 people in attendance.

TRINITY PASS ROAD IN WINTER. This is a photograph of Trinity Pass Road as it passes Trinity Lake while looking south. The photographer's horse-drawn sled has left tracks in the snow.

TRINITY PASS ROAD IN SUMMER. This is a photograph of Trinity Pass Road as it passes Trinity Lake while looking north.

SQUATTERS ON TRINITY LAKE. In the early 1900s, the lake was used for recreational purposes until this privilege was abused by squatters and careless visitors. In the years before World War I, the squatters pitched tents on the lakeshore and traveled by bicycle to jobs in New Canaan. When one of the women was observed washing her laundry in the reservoir, the water company routed the squatters and put an end to the public use of the lake for recreation.

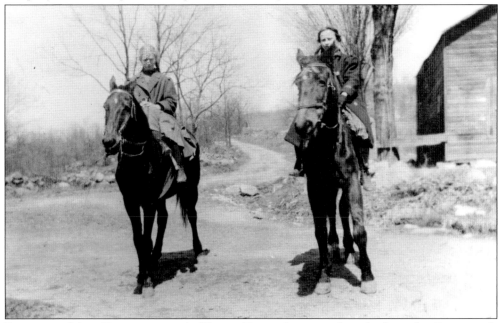

RIDING BY MRS. BUTTERWORTH'S HOME. Two girls are on horseback at the Butterworth house in Scotts Corners on Trinity Pass at Westchester Avenue. The Butterworth home in the background was on the northeast corner of the intersection with access from Trinity Pass. It was torn down when the Scotts Corners Shopping Center was built.

RAYMOND, SLAUSON HOME. This Trinity Pass Road home, just west of the bridge at the intersection of Trinity Pass and Old Mill River Road, is mentioned as early as 1802 in a deed whereby the heirs of John Raymond sold a house and barn with 140 acres to Nathan and John Slauson. The original barn was on the south side of Trinity Pass. (Courtesy of Regina Kelly.)

BENAJAH BROWN HOUSE. Benajah Brown was born in 1749 and is listed on the 1777 roster of Poundridge patriots. During the Revolution, he served as first lieutenant in the 4th Regiment of militia. He built this Old Mill River Road house shortly after the Revolution across the road from a mill site. The house has a center chimney and low ceilings. The storefront window came from a shop in England.

Six

SCOTTS CORNERS

In the 1700s and early 1800s, what is known today as Fancher Road to Barnegat Road was the main route to Norwalk and New Canaan (see map on page 2). Westchester Avenue, south of Fancher Road to the New Canaan line, did not exist until the mid-1800s. Scotts Corners started to appear as a settlement after this new road was built. The community known as Dantown (now called Lost District) was on Lower Trinity Pass in the area now occupied by the Laurel Reservoir in Stamford. It was named for the Dans, wealthy mill owners.

Dantown was known for its basketry, called Dantown Crockery. Almost all Dantown men were expert basket makers. Basketry reached its zenith in the years just following the Civil War. Local trees, hickory, ash, and oak, were used. The young trees were cut in winter and kept pliable by submerging them in ponds until they were ready to be sliced, pounded, and shaved into splints ready to be woven.

The first Methodist Society church in New England was in Poundridge just a few feet north of the Connecticut/New York border and served the Dantown community. In 1797, a church was built on land given by the miller, Squire Dan. In the early part of the 19th century, doctrinal differences split the church into two factions: reformers, who no longer looked to John Wesley as the head of the church, and the older and more traditional old-fashioned Methodists. These factions strained the financial support and attendance at the Dantown church. In 1844, the church was forced to close, and, in an apparent rage, the minister, Rev. Frederick Sizer, ordered this shrine of early-American Methodism torn down. The tiny cemetery still stands shaded on a small hill, and the weathered stones bear the names of Sellecks, Dans, and Hoyts.

Over 80 Scotts Corners families were engaged in basket making at its peak. Poundridge baskets became so famous that Scotts Corners was called Basket Town. Many of their products were sold through Weed's Store in New Canaan. Since the poor basket makers bought consumer goods at Weed's against their future production, it resulted in virtual debt servitude for many of them.

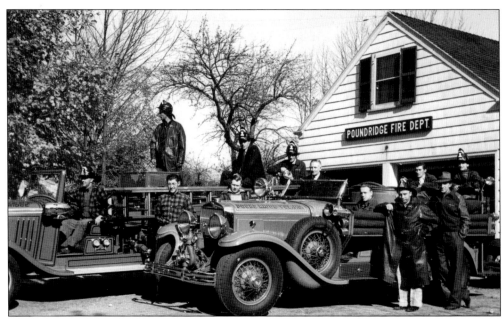

VINTAGE FIRE TRUCKS. The Poundridge Volunteer Fire Department was established in 1934 from a committee formed by the Trinity Property Owners Association. This 1937 photograph is of the first fire trucks purchased. Hiram Halle donated $1,000, half the proceeds needed, with townspeople raising the rest. The Chevy fire truck is still proudly paraded by the volunteer fire department.

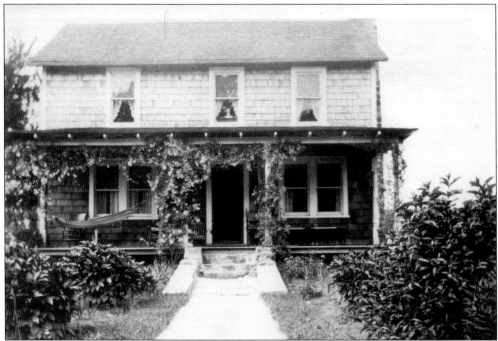

BAILEY-FITZNER HOUSE. This 1925 photograph shows the Bailey-Fitzner house, which was located on the south side of Westchester Avenue. William E. Bailey purchased the property in 1922, and his wife sold it in 1948.

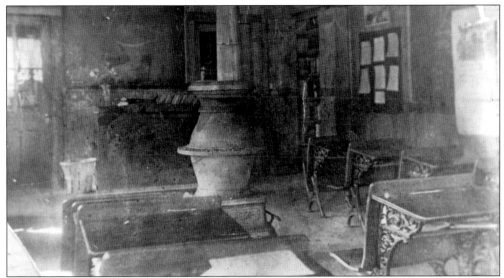

CHILDREN AND ROCK SCHOOL HOUSE. The above 1920 photograph shows the one-room schoolhouse on Trinity Pass and Barnegat Roads. As one of the original schools, it appears on the 1851 map. When Eleanor Roosevelt visited her literary agent on Trinity Pass in 1936, she was taken to see this school, which she pronounced "awful." The children, who were accustomed to raccoon or possum sandwiches in their lunch boxes, were not aware that their school facilities were so primitive. All the one-room schools were sold at auction in 1939. The Rock School, sold to Fred Barker, brought the lowest price at $500. Pictured below are, from left to right, (first row) Lawrence Barker, Frances Sefcik, Hilda Wilkenloh, Carl Bouton, Fred Barker, Joe Sefcik, and Jimmy Wilkenloh; (second row) Mrs. Gelleck, William Wilkenloh, Anna Sefcik, Hermina Sefick, Lester Barker, and Mrs. Sellect; (third row) Ruth Harris, Dorothy Scofield, Mrs. Barker, Mae Bouton, and Mrs. Sefcik.

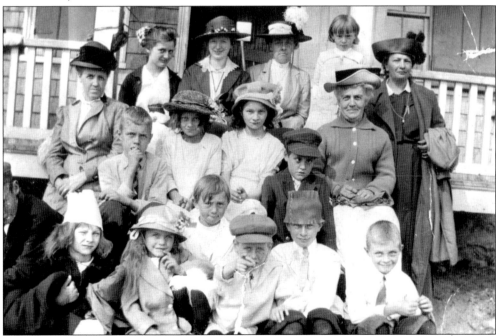

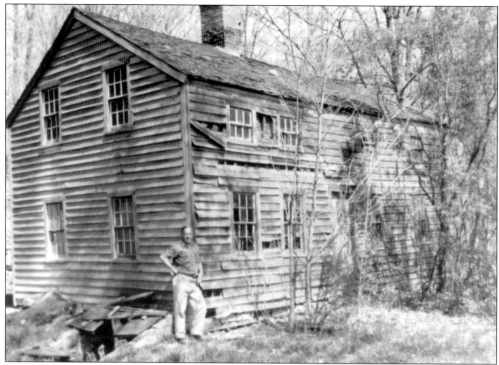

SELLECK/BENDER HOME. This Westchester Avenue home was built by Nelson Selleck about 1840 and is identical to the adjacent house of his brother Sands Selleck. In 1950 it was purchased and restored by Helen Bender. There is also a restored basket shop on the property which was used by the Selleck family to sell their goods. Bender Road is named after the Bender family, who restored many homes in Pound Ridge.

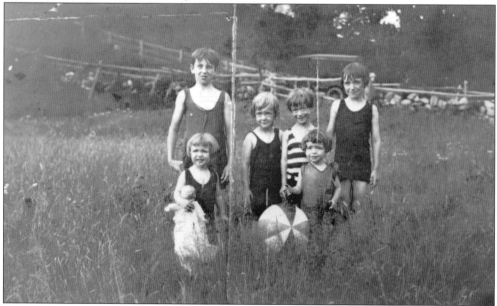

SUMMER FUN. This pre-Depression-era photograph shows a family of Poundridge children ready for summertime fun.

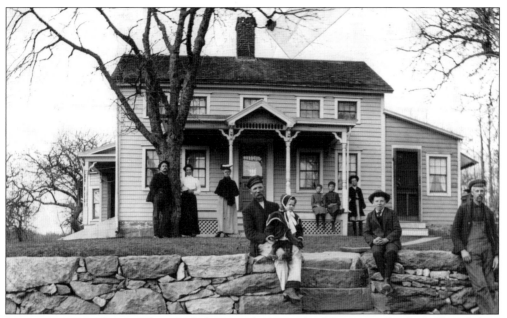

SANDS SELLECK HOUSE. This 1906 photograph shows the following individuals, from left to right: William Harris, Lulu Harris, Sarah Selleck, Sivori Selleck with granddaughter Ruth Harris, Clara Ruscoe, Mary Ruscoe, Ethel Scofield, Fred Ruscoe, and Lincoln Jones. The house was built about 1841 by Thomas Tong, a local carpenter, during the time Westchester Avenue was laid out.

SCOFIELD FAMILY AND BLIND CHARLIE SCOFIELD. This Westchester Avenue home was torn down. It shows the Scofield family, including Blind Charlie, a blind basket maker.

WILLIAM SCOFIELD FARM. This house was built about the time of the construction of the new road to New Canaan, Connecticut, in 1840. The property is first mentioned in an 1846 deed of sale by Willard Weed. In 1855, William Scofield purchased the property and maintained a large farm there until his death in 1881. The two-story house with attic is probably the original configuration.

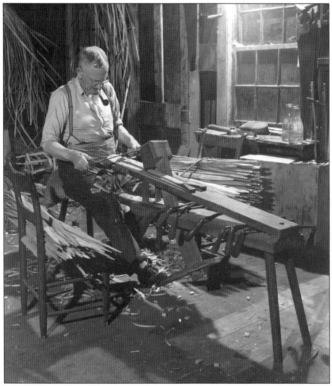

BASKET MAKING BY FRED SCOFIELD. The making of oyster baskets was an important industry in Poundridge from the mid-1800s through the early 20th century. Automation of basket making eliminated this Poundridge industry and led to a significant decline in population.

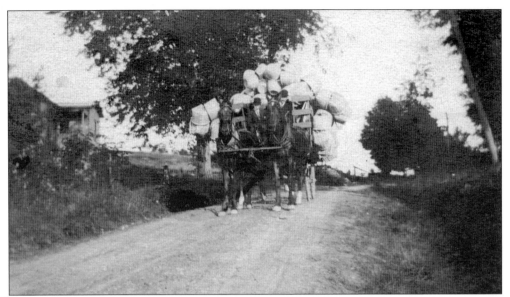

BASKET CART TO MARKET. In its economic heyday, Pound Ridge was a local basket-making mecca. Here, around 1900, basket makers are transporting their goods to New Canaan, Connecticut, where they would be sold for use in oyster fishing. They were transported to New Haven, then down the Connecticut coast, across lower Westchester, up the Hudson River to Poughkeepsie.

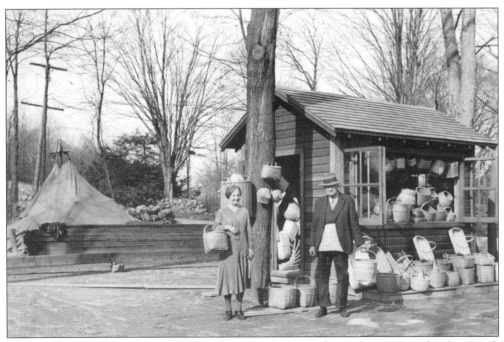

SELLECK BASKET SHOP. Frank Selleck was one of the last basket makers in Pound Ridge. Frank is depicted here with his wife Lizzie in front of his shop. In 1932, Frank Selleck built a small white building at the southwest corner of Trinity Pass Road and Westchester Avenue in which he lived and ran a grocery store. In October 1937, he moved this small building to the northwest corner and began a trade of basket making. (Courtesy of Judy Carman Tomlins.)

FRED BENNETT SCOFIELD BASKET FACTORY BUILDING. This is the basket factory of Fred Bennett Scofield. The interior of the building on the right is detailed on the front cover of this book. Fred Bennett Scofield purchased the house and property at the southeast corner of Westchester Avenue and Lower Trinity Pass Road.

TRINITY PASS AND WESTCHESTER AVENUE. This photograph shows Dorothy Scofield on her horse and is believed to be at the intersection of Trinity Pass Road and Westchester Avenue.